Creative Alcohol Inks

A STEP-BY-STEP GUIDE TO ACHIEVING AMAZING EFFECTS

Ashley Mahlberg

QUARRY

MW00997079

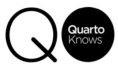

Brimming with creative inspiration, how-to projects, and useful information to enrich your everyday life, Quarto Knows is a favorite destination for those pursuing their interests and passions. Visit our site and dig deeper with our books into your area of interest: Quarto Creates, Quarto Cooks, Quarto Homes, Quarto Lives, Quarto Drives, Quarto Explores, Quarto Gifts, or Quarto Kids.

© 2020 Quarto Publishing Group USA Inc.
Text © 2020 Ashley Mahlberg
Photography, design, and presentation © 2020 Quarto Publishing Group USA Inc.

First Published in 2020 by Quarry Books, an imprint of The Quarto Group,
100 Cummings Center, Suite 265-D, Beverly, MA 01915, USA.
T (978) 282-9590 F (978) 283-2742 QuartoKnows.com

All rights reserved. No part of this book may be reproduced in any form without written permission of the copyright owners. All images in this book have been reproduced with the knowledge and prior consent of the artists concerned, and no responsibility is accepted by producer, publisher, or printer for any infringement of copyright or otherwise, arising from the contents of this publication. Every effort has been made to ensure that credits accurately comply with information supplied. We apologize for any inaccuracies that may have occurred and will resolve inaccurate or missing information in a subsequent reprinting of the book.

Quarry Books titles are also available at discount for retail, wholesale, promotional, and bulk purchase. For details, contact the Special Sales Manager by email at specialsales@quarto.com or by mail at The Quarto Group, Attn: Special Sales Manager, 100 Cummings Center, Suite 265-D, Beverly, MA 01915, USA.

10 9 8 7 6 5 4 3 2

ISBN: 978-1-63159-791-6

Digital edition published in 2020
eISBN: 978-1-63159-792-3

Library of Congress Cataloging-in-Publication Data

Mahlberg, Ashley, author.
Creative alcohol inks : a step-by-step guide to achieving amazing
 effects--explore painting, pouring, blending, textures, and more! /
 Ashley Mahlberg.
ISBN 9781631597916 | ISBN 9781631597923 (eISBN)
1. Ink painting--Technique. 2. Alcohol--In art--Technique.
LCC TT385 .M327 2020 (print) | LCC TT385 (ebook)
 745.7/23--dc23

LCCN 2019039434 (print) | LCCN 2019039435 (ebook) |

Design: Allison Meierding
Page Layout: Megan Jones Design
Photography: Steve Johnston, exposureleak.com

Working with alcohol inks and other materials in this book can be dangerous if proper safety procedures are not followed. Materials are flammable and let off toxic fumes. Failure to follow safety procedures may result in serious injury or death. This book provides useful instruction, but we cannot anticipate all of your working conditions or the characteristics of your materials and tools. For your safety, you should use caution, care, and good judgment when following the procedures described in this book. Consider your own skill level and the instructions and safety precautions associated with the various tools and materials shown. The publisher cannot assume responsibility for any damage to property or injury to persons as a result of misuse of the information provided.

Printed in China

This book is dedicated
to my husband.
Ray, I'm forever grateful
for your love and
encouragement.

Contents

Introduction

WELCOME TO *CREATIVE ALCOHOL INKS*! I'm so thrilled to have been given the opportunity to share this magical fluid medium with you. I receive emails and comments every day from people wanting to learn about how to master alcohol ink. Because I'm a one-woman show working out of my home studio, I don't have the time to be able to respond to every inquiry, as much as I'd love to, so I've written this book to respond to the most frequently asked questions.

In this book, you'll find a complete supply list, an in-depth chapter on basic techniques, and twelve step-by-step projects that will get you comfortable working with alcohol ink and give you the confidence to create your own works of art. I've done my best to really share my process from start to finish, which is why I also included information on my go-to color palettes, sealing your work, creating fine art prints, how to frame your work, and more.

Because alcohol ink is a fluid medium, the low level of control you have can be intimidating to people who haven't dabbled in fluid art. I'll teach you how to work with the fluid nature of this medium instead of against it to confidently create those stunning alcohol ink pieces you see all over social media. Learn the basic techniques I've laid out for you and let the alcohol ink show you what it can do!

Ashley Mahlberg

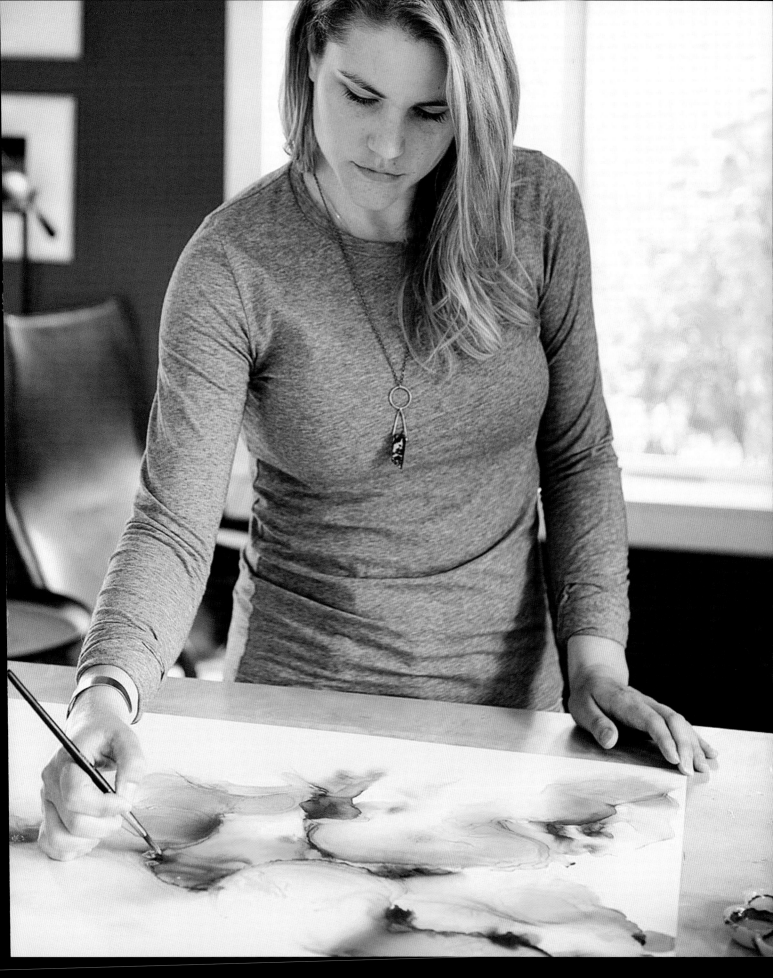

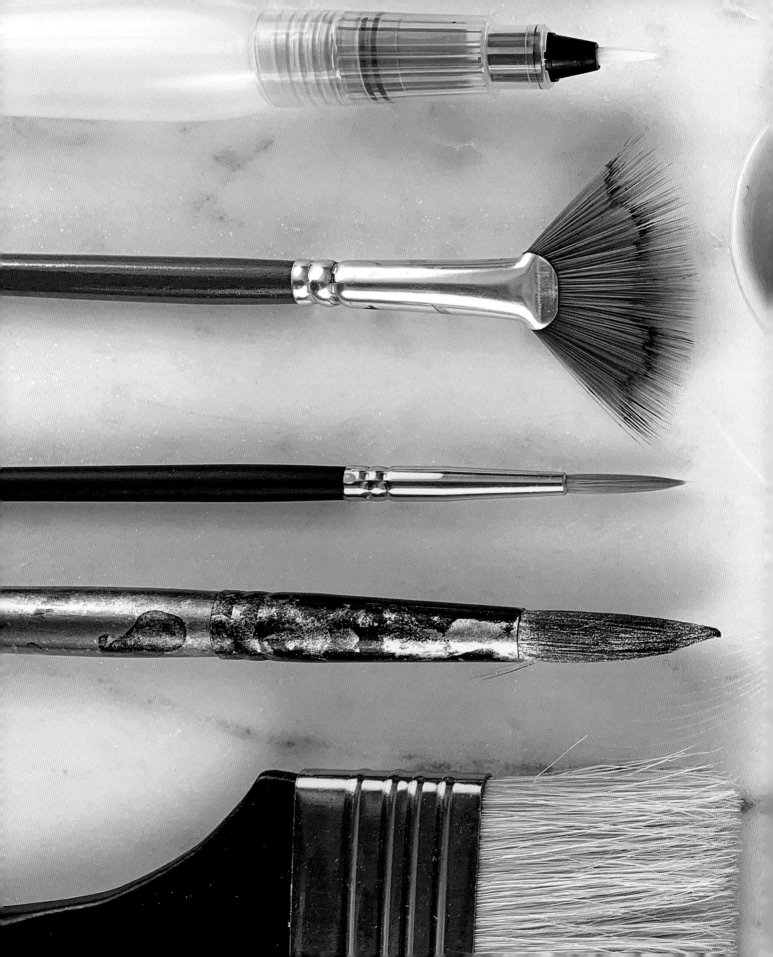

1

Essential Supplies

HAVING A NICE RANGE OF ART SUPPLIES on hand is helpful when experimenting with a new medium, but what's great about working with alcohol ink is that the basics are just that—basic! The investment is minimal and the results are magical. All you need is alcohol ink, isopropyl alcohol, and a surface on which to start creating. That said, to become fluent in this exciting medium and experiment with the techniques and projects I've laid out for you, I highly recommend purchasing all the extra supplies. Most of the extras are fairly basic, and you may already have them in your art supply stash.

Alcohol Inks

Alcohol ink is a translucent, acid-free, highly pigmented fluid medium intended for applying to a nonporous surface. Alcohol ink is made of dye and alcohol; the alcohol is what gives the dye its fluid nature, and the alcohol evaporates as the dye dries. The textures, color palettes, and compositions you can easily achieve are absolutely second to none, resulting in an extremely addictive medium! Not only can you create stunning effects with it, but the versatility is an incredible quality as well. When working with alcohol ink, you have its ability to reactivate dry paintings and completely rework or fix mistakes without difficulty.

Alcohol ink is available in dropper bottles for easy application directly from the bottle onto your surface. With such a broad color offering, the palettes you can create are limitless. With alcohol ink quickly gaining popularity, more and more local art stores are beginning to carry larger selections; however, at the moment the big online art companies offer the largest alcohol ink options in one place. I use three alcohol ink brands: Brea Reese, Tim Holtz, and Copic Various Refills. I prefer these brands, but I encourage you to experiment with all varieties and discover your own favorites. Don't feel like you have to stick to one brand either; I often paint one project using all three brands.

One of the best qualities of alcohol ink is that most colors let you reactivate the medium to rework a piece. Knowing which colors are more likely to let you rework them is helpful to know and plan for before you start painting. As you experiment with different alcohol ink brands and colors, you will notice a difference in the ratio of alcohol to dye in each bottle. Some colors have a higher concentration of isopropyl alcohol or dye than others; you'll notice this simply by how much your alcohol ink moves on its own straight out of the bottle as it's applied to a surface. If the alcohol ink has a higher dye concentration, it's easier to reactivate and rework because there's dye or color available to move around your surface. Alternatively, if there's a higher ratio of alcohol than dye, reactivating the color and reworking it is a little harder. Instead of trying to rework those colors, I recommend applying more alcohol ink directly from the bottle to the portion of your project where you want a greater concentration of color.

ALCOHOL INK BRANDS	RANGE OF COLORS	PACKS	SIZE	NOTES	AVAILABLE IN METALLIC MIXATIVES
Brea Reese	25	9 packs of three	0.68 ounce (20 ml)	Easily found at your local art and craft stores, it can be purchased in packs of three, making it easy to have a harmonious color palette right out of the box.	Yes
Copic Various Ink Refills	358	0	0.85 ounce (25.13 ml)	Copic has the largest color range and a very helpful printout of all the colors on their website.	No
Jacquard Alcohol Ink Pinata Color	27	2	½ fl ounce (14.79 ml) select colors are available in 4 fl ounce (118.29 ml) and 1 gallon (3.79 L)	Most commonly available in sets of nine. This brand is a little harder to find individual bottles unless you are buying a metallic mixative. I prefer their metallic mixatives.	Yes
Ranger Tim Holtz Alcohol Inks	71	23 packs of three	0.5 ounce (14.79 ml)	Easily found at your local art and craft stores, it can be purchased in packs of three, making it easy to have a harmonious color palette right out of the box.	Yes
Spectrum Noir Marker Ink Refills	208	0	1 ounce (30 ml)	This alochol ink comes in a glass bottle with a dropper to apply alcohol ink.	No

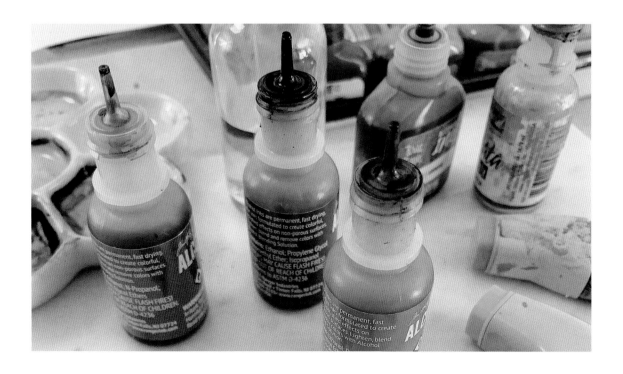

Blending Liquids

Blending liquid is essential to the pouring, blending, and mixing of alcohol ink. It's used to lighten highly pigmented alcohol ink as well as to help move the ink fluidly across a surface. Blending solutions can be found at art and crafts stores. I prefer to use isopropyl 91 percent, which can be purchased inexpensively from most drugstores.

The main difference between isopropyl and blending solution is how the alcohol ink reacts and blends with each liquid. Blending solution offers a faster blend, smoother transitions, and fade-outs, which can mimic the look of watercolor paintings. Isopropyl is the opposite, in that it's slower to blend, and you have to work a little more with your air tool (see opposite) to achieve softer blends and fade-outs. However, because you can achieve the same effects with both, and isopropyl is more cost-effective than blending solution, I favor the isopropyl because

I use quite a lot at one time. I recommend experimenting with both to see which you prefer.

If after experimenting with blending liquids you prefer the blending solution to the isopropyl, you can mix your own using the recipe below. This is less expensive than the store-bought option and you can mix larger quantities to have on hand when working on larger projects. The glycerin acts as an extender, so the alcohol ink stays wet longer than if you were using just straight isopropyl.

DIY BLENDING SOLUTION

- 6 ounces (180 ml) isopropyl alcohol 91%
- 12 drops vegetable glycerin

Fill a squeeze bottle with a small tip with the isopropyl and add the vegetable glycerin with a dropper. Give it a good shake and you're good to go!

Air Tools

To move the ink across your surface, you'll need to use one of the air supplies listed below. I use all of these in my work, depending on the effect I want to achieve.

Embossing heat tool. This is my preferred air tool when working with alcohol ink. The texture and layering effects that can be achieved with this tool are truly fascinating. You will need to be mindful when using a heat tool to not focus the heat in one place for too long because it can start to warp or melt your paper.

Hair dryer. Unlike the embossing heat tool, the hair dryer's heat is less intense and isn't as concentrated in one direction, making it easier to quickly cover a surface with an alcohol ink wash. I often use the cool setting when painting ink washes on a larger scale, so my ink wash doesn't dry as quickly, giving me more time to work with a wet layer.

Canned air. Canned air forcefully pushes alcohol ink across the surface, resulting in paintings bursting with really beautiful movement and textures.

Straw. A straw is a popular and simple way to move ink across a surface. Using a straw allows you to achieve a more direct airflow in one spot and avoid disturbing the alcohol ink in other areas of your painting.

Airbrush. Out of all the air tools, this is the one I use the least, but that doesn't mean it's not useful to have on hand for those occasions when I want a less intense canned-air effect.

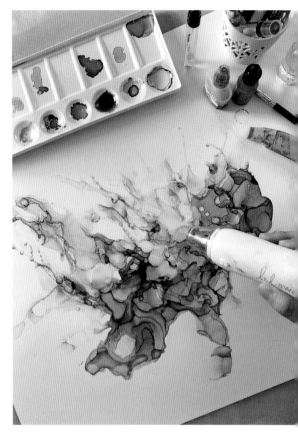

Using an embossing heat tool to move alcohol ink on a surface

Surfaces & Substrates

Many surfaces take alcohol ink beautifully. With the exception of Claybord, the one thing they all have in common is that they're nonporous in nature. A nonporous surface allows the alcohol ink to sit on top of the surface, giving you the ability to easily manipulate the flow of the medium with your air tool.

Yupo paper. Yupo is the most common surface used for painting with alcohol ink. This smooth-as-butter waterproof synthetic paper is strong and durable, and the effects you can achieve are magical. You can purchase Yupo paper in pads, loose sheets, or rolls. It is available in transparent, medium, and heavy weights.

Smooth painting Gessobord (panel). When selecting a painting panel, make sure it has a smooth gesso finish, which allows the ink to move fluidly across the surface. Painting panels typically come in various thicknesses ranging from ⅛ inch to 2 inches (3 mm to 5 cm).

Claybord. The only surface I use that absorbs alcohol ink is Claybord. This velvety smooth clay surface is the perfect ground for taking ink washes and then using sharp tools to scratch out designs. Claybord is more readily available for purchase online than in stores. This panel also comes in various thicknesses ranging from ⅛ inch to 2 inches (3 mm to 5 cm).

Waterproof panels. These panels are a new surface option that is similar to Yupo paper in that they are waterproof, but the paper is wrapped around a sturdy piece of greyboard. These panels can be found in most art stores.

Canvas. Canvas requires a little extra prep before it can accept alcohol ink. To create a less porous canvas, you'll need to apply three coats of water-based primer (I use Kilz 2), which you can find at any home improvement store. I use this surface the least because I don't like the time it takes to prep the panels.

Glazed ceramic or porcelain. One of the most exciting features of working on porcelain or glazed ceramic is the ability to completely wipe off the ink with straight isopropyl and rework a piece if you are unhappy with the results. You can also achieve really pretty textures with a heat tool without fretting about the heat warping the surface.

Alcohol ink cardstock. This glossy cardstock surface creates lovely fades and bleeds that I haven't been able to replicate on any other surface. The cardstock is also conveniently pre-cut to standard card sizes 4¼" × 5½" (10.8 × 14 cm) and 5" × 7" (12.5 × 18 cm), which are perfect for craft projects.

Alcohol ink art panel. This surface is double-sided vinyl mounted to a hard core MDF board, offering the flexibility to work both sides and choose your favoritpainting to display. Lightly textured, it means the ink moves less fluidly across the surface, which is nice when you want more control over the flow of your piece.

Experiment! I'm always testing out new surfaces and I encourage you to do the same. It's exciting to discover a new surface and experiment with how the alcohol ink effects will react to it. I know artists who create lovely paintings on acrylic, glass, aluminum panels, and stamping paper.

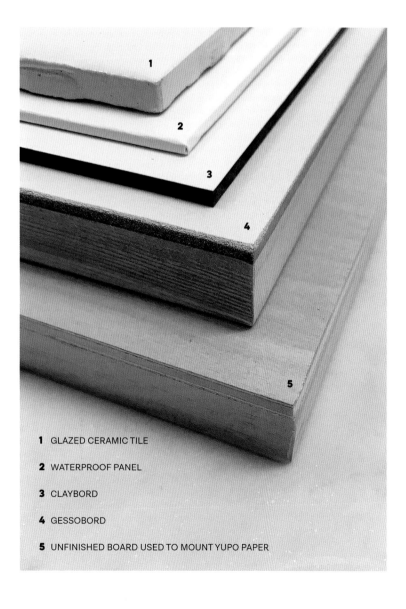

1 GLAZED CERAMIC TILE

2 WATERPROOF PANEL

3 CLAYBORD

4 GESSOBORD

5 UNFINISHED BOARD USED TO MOUNT YUPO PAPER

Other Supplies

There are a myriad of supplies that will help you take your alcohol ink paintings or projects to the next level, adding details, textures, and movement that the medium cannot achieve with just the basic supplies. I keep all of the following extra supplies on hand in my studio, and I'm always on the lookout for tools to create new and innovative effects. The projects in this book may call for supplies not on this list, so be sure to check the materials lists before you get started.

Masking pens. These are filled with a liquid repellent masking fluid, allowing you to paint over the mask with alcohol ink and remove it after the ink has dried, exposing the white of your original surface. My favorite brands are Pebeo and Molotow.

Palette. I always have a few palettes on hand in my studio. I prefer porcelain because it is heavy enough that it won't move around on my worktable, but plastic works just as well for holding isopropyl and alcohol ink.

Squeeze bottle or dropper. I stockpile 50 ml (1.75 oz) squeeze bottles purchased from my local craft store. They are helpful when applying isopropyl or a mixture of alcohol ink and isopropyl to a surface. The caps are pointed for a more controlled application. Dropper bottles are also a nice alternative for applying isopropyl to your pieces.

Paint pens. After you have varnished your alcohol ink painting (see page 64 for this process), you can safely draw on top with paint pens, gel pens, Micron pens, or whichever drawing tool you prefer and the pens will not reactivate the ink.

Modeling texture. This paste is applied to the substrate and hardens when dry, creating a textured layer that you can paint over with alcohol ink.

Metallic mixatives. Mixatives can be combined with alcohol ink to create metallic highlights. There are a few brands on the market, but I prefer the Jacquard Piñata mixatives.

Paintbrushes. It's always nice to have a mix of paintbrushes on hand. I use various rounds, my favorite size being a #10, a fan brush, and a couple of large flat brushes, usually between 1½ inches and 2½ inches (3.8 cm and 5 cm). A refillable brush is also perfect for filling with isopropyl or alcohol ink. I prefer the refillable brushes from Brea Reese because of the varied brush sizes offered, but any brand will work.

Eraser tools. These are inexpensive and useful for removing masking fluid and creating textures by dragging them across a wet alcohol ink wash.

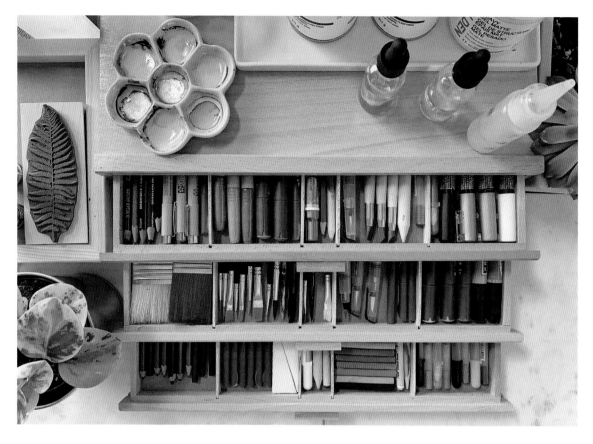

Mister or spray bottle. Filling a small spray mister with isopropyl creates a beautiful speckled effect when sprayed over an alcohol ink surface.

Wedge. Also called a catalyst, a wedge is a silicone hand tool that creates striking textures as you scrape, drag, or dab the tool over an alcohol ink painting.

Embossing powder. Embossing designs or lettering over your ink washes is an exciting way to add dimension and shimmer to a painting. I work with embossing powders from Ranger Ink, but there are many brands to choose from.

Acrylic paint. It's a good idea to have several basic acrylic paints readily available. I use acrylic to add details to my paintings or to paint the sides of Claybord or Gessobord panels.

Painter's tape. I use 2-inch (5 cm) painter's tape to tape off the sides of Claybord and Gessobord panels to protect against any resin or alcohol ink that drips down the sides of a panel.

Safety supplies. See page 20 for details.

Contact paper and adhesive stencils. Cut your own stencils out of contact paper or buy a store-bought adhesive stencil to add unique patterns to your paintings.

Sealants

If not sealed correctly, alcohol ink can reactivate or fade. Below are supplies to help protect your alcohol ink creations. See page 64 for directions on sealing your projects.

Kamar varnish spray. This spray will keep the alcohol ink from activating, but you still need to be careful handling it because the natural oil from your hands can transfer to the surface. I recommend applying three layers of varnish to each piece to ensure the painting is set and impervious to the elements.

UV protector spray. All original art is subject to fading over time, so a UV protector is very important for prolonging its life. Displaying art in a place that doesn't receive direct sunlight will also slow the fading process. Use the UV protector on all your projects, not just the fine art paintings. This sealer also requires three coats for even coverage and protection.

Triple-thick clear glaze spray. This sealant is perfect for pieces that will be handled more than a fine art painting, such as ornaments or picture frames. That said, you can still apply the triple thick glaze to fine art pieces that don't flex, such as Yupo mounted to board or a Gessobord painting. This sealant gives the art extra protection and a pretty, shiny, glazed look. I usually apply two or three coats, letting it dry completely between applications.

 Note: Do **not** use this product with surfaces or pieces that flex or the glaze will lift and peel off.

Resin. Using resin is a lovely way to make the colors in your paintings pop due to the glassy effect it creates, but more important, it gives an extra layer of protection from UV rays, dust, and oils that could land on your painting. I use the brand ArtResin because it doesn't yellow and is nontoxic and, therefore, free of VOCs and fumes when used as directed. It's even food-safe! Feel free to experiment with other brands and find the one that's right for you.

SEALANT SAFETY

Review all the risks and safety precautions on product labels.
- Apply sealant outside or in a well-ventilated space.
- Wear all safety equipment outlined on page 20.

For additional safety information and guidelines, see pages 20–21.

Setting Up a Workspace

I always set up my workspace prior to painting. Properly protecting your table and yourself, and being aware of your positioning, are all necessary to your process. If you constantly have to stop your creative flow to clean up spills, then you can't be fully immersed in the process. The following are a few ways I prepare before painting.

Alcohol ink requires you to be able to work quickly from all directions. You can't always anticipate where the alcohol ink will flow, so it's helpful to be able to move easily around your worktable to adapt to the flow of the alcohol ink. So

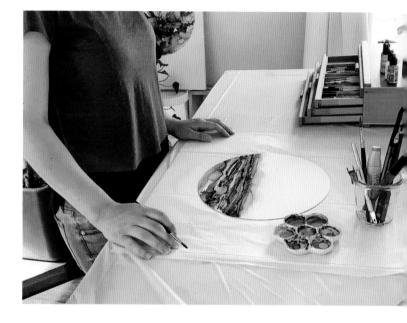

that I can be flexible when painting, I prefer to stand at a counter-height worktable. Alcohol ink is permanent, so make sure you protect anything in your workspace that you don't want the ink to touch. Place a plastic table-cloth on your worktable and stack a few sheets of tissue paper on top to absorb the excess ink that will pour or spatter off a project.

Be mindful of how long you are standing or what you're standing on; a full day of standing on a cement floor can easily turn into a couple of days of discomfort. Always stand on a mat that has extra cushion. Consider mats that are used for commercial kitchen spaces; they are super comfortable and you can easily wipe off any spills.

Because alcohol ink will stain your clothing, and unless you have specific painting clothes, you may want to purchase an apron to wear while working. I like to wear a thick denim apron that absorbs the ink quickly before seeping through to my clothing. I use the Vantoo brand; there are other quality aprons out there as well.

Working Safely

Alcohol ink, isopropyl alcohol, and blending solutions are all flammable and let off toxic fumes due to the alcohol and ethanol, so make safety your first priority when using these substances, especially because applying heat is a significant part of the process. When creating those beautiful textures and layers, make sure you're aware of the risks involved and take care to minimize them to keep you and others around you safe.

- **To stay safe, read the manufacturer's guidelines and warnings on the back of isopropyl alcohol ink, and blending liquid before use.**
- With the exception of the photography in this book, every time I paint with alcohol ink I wear a respirator mask, goggles, or safety glasses and nitrile gloves. I turn on my air purifier and open all doors and windows in my studio to get as much clean air circulating as possible.
- Make sure there's no one else in your studio while you are working unless they're also wearing a mask.
- Never let children paint with alcohol ink. I don't even let my child around me when I'm painting because of the many risks involved.
- Wear a mask, goggles, or safety glasses, and gloves while applying sealant. Do so in a well-ventilated area. I only apply sealant in my garage with the garage door open to the outside.

MUST-HAVE SAFETY SUPPLIES

Respirator mask. Research and purchase a mask that works best for you, and use it every time you work with alcohol inks. I use a 3M half facepiece made especially to protect against volatile organic compounds (VOC).

Nitrile gloves. Use these to keep your hands free of alcohol ink and isopropyl. You can find them at home improvement stores.

Goggles or safety glasses. These are essential for eye protection, because you never know when a random splash of alcohol ink or isopropyl will spray you in the eye.

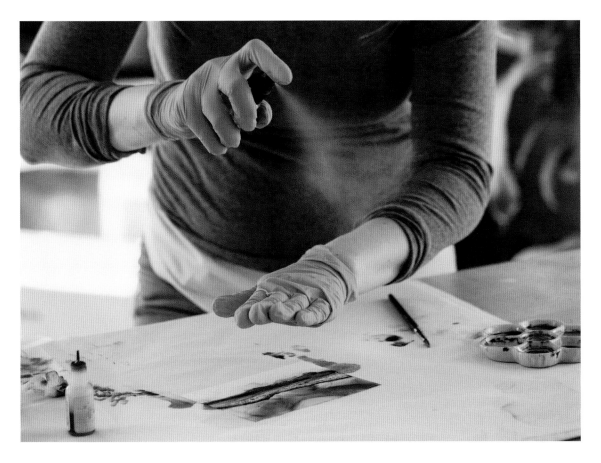

Always wear a respirator mask, goggles or safety glasses, and nitrile gloves to protect yourself from the risks of working with alcohol inks and related products.

Butane Torch Safety

When applying resin to your finished pieces (see page 70), you can use a butane torch to pop the bubbles that can develop after it's applied.

Please be aware of the risks involved with using butane in enclosed spaces, and use extreme caution when working with an open flame. Before using a torch, clear your work area of all alcohol inks, isopropyl alcohol, blending solutions, and any other flammable mediums or material. Be sure to read all the manufacturer's warning labels so you can safely use the product. Alternatively, you can use an embossing heat gun to pop the bubbles, but it's not as effective if the resin has many bubbles in it.

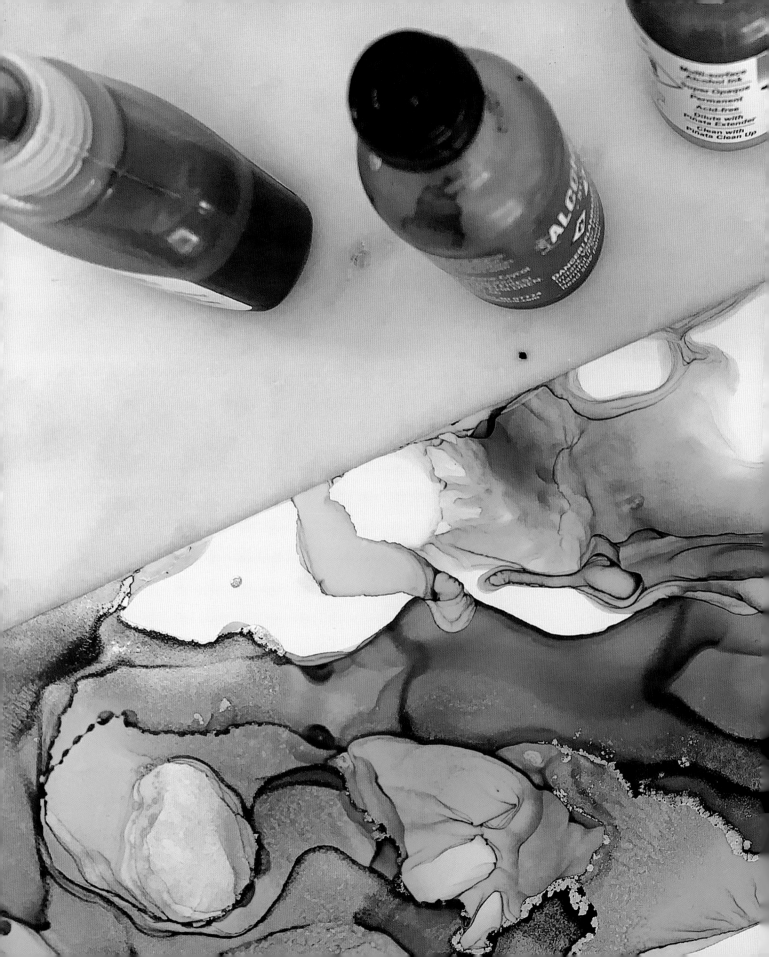

2
Basic Techniques

ALCOHOL INK ON ITS OWN, without any added embellishment, is a truly magical and exciting medium. Just the flowy, organic compositions of the alcohol ink alone are enough to stop you in your tracks. However, there are a few basic techniques that can really help bring your paintings or projects to the next level. What makes the techniques in this chapter even more thrilling is how simple they are! Try combining techniques or practicing the same technique on different surfaces and observe how the alcohol ink reacts to each one. This is where you can play with the process and develop your skills to create those awe-inspiring alcohol ink paintings.

Alcohol Ink Wash

The essential first step and the foundation of an alcohol ink painting is creating an alcohol ink wash. To create an alcohol ink wash, pour isopropyl onto the surface, drop alcohol ink directly from the bottle onto the isopropyl, and use your heat tool to blend and move the ink across the surface. Because this technique is so crucial to the success of your paintings, take the time to practice painting ink washes before moving on to the other techniques in this chapter.

 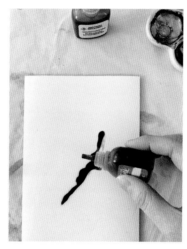 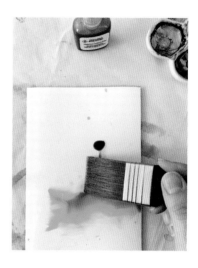

1 Start by placing a 5" × 7" (12.5 × 18 cm) piece of Yupo paper on your worktable. Pour about ½ ounce (15 ml) of isopropyl onto the paper and use a flat brush (I used a 1½" [3.8 cm]-wide brush in the photo) to quickly distribute the isopropyl over the entire paper.

2 Now drop your chosen alcohol ink color onto the paper.

3 Brush the ink around the surface to get a good base.

WORK QUICKLY

Isopropyl evaporates quickly, so when creating an ink wash you need to move fast. Don't worry—even if it does evaporate, you can always add more.

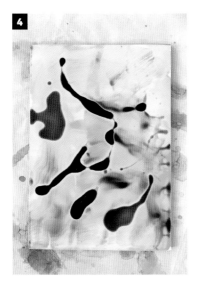

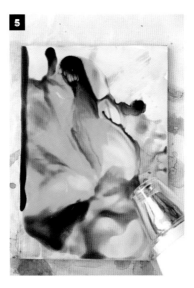

4 Drop more isopropyl and alcohol ink directly from the bottles onto the paper. I used three different alcohol ink colors on my wash. There is no set ratio of alcohol ink to isopropyl you must use to create a wash. When the isopropyl outweighs the amount of alcohol ink in the mixture, it will create a lighter palette; when the alcohol ink outweighs the isopropyl, the palette becomes more saturated.

5 Using a heat tool, push the drops of alcohol ink across the Yupo paper in all directions, covering the entire paper. If the ink stops flowing easily, simply add more alcohol ink and/or isopropyl to the paper and continue with the heat tool. Be mindful not to concentrate the heat tool in one place for too long, because the paper can start to warp. As the painting begins to dry, notice the stunning depth and textures you have created! Keep practicing with this technique by repeating steps 3 through 5 on top of your ink wash and observing how the new wash reacts with the wash underneath, creating new textures and forms.

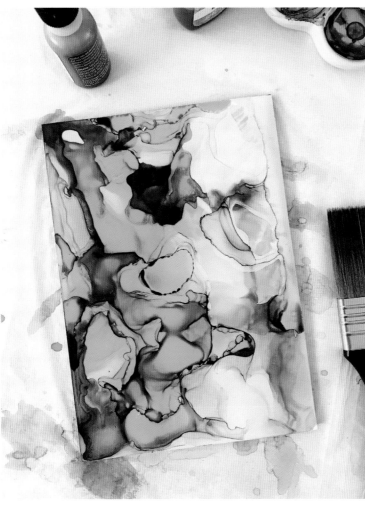

Stippling to Create Blooms

One of my favorite techniques is creating little "blooms" using the stippling effect. When isopropyl or a mix of isopropyl and alcohol ink is stippled onto the surface of an alcohol ink wash, little circles form as the isopropyl pushes the ink wash in all directions, exposing more of the paper underneath the ink wash and creating blooms.

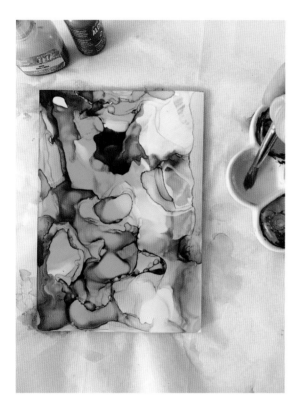

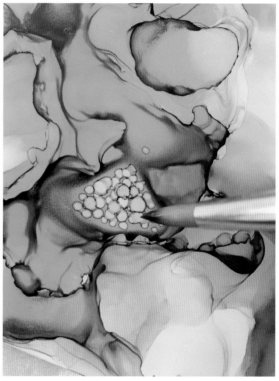

1 Use the alcohol ink wash that you created in the previous technique, or paint a new wash and place the dry piece on your worktable. Fill one of your palette wells with straight isopropyl and dip a medium round paintbrush (here, I use a #10 round) into the isopropyl. Dab a little isopropyl off the brush onto a paper towel. (If the brush is too full, it is harder to control the size of the bloom.)

2 With the tip of the wet brush, stipple lightly on the ink wash wherever you like and notice little dots begin to bloom. The dots will continue to blossom until the isopropyl has evaporated, or you can stop the bloom by simply blowing on top to hasten the drying process.

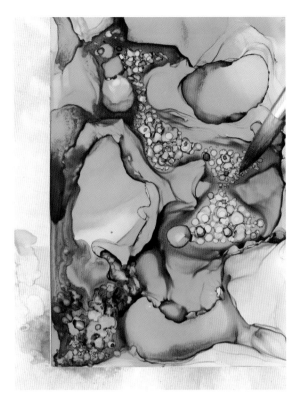

3 Play with this technique by completely filling the brush with isopropyl and dropping it on the ink wash—the more isopropyl you drop down onto the surface, the bigger the bloom. To add colorful blooms, experiment with dipping your brush into straight alcohol ink and layering over the isopropyl blooms.

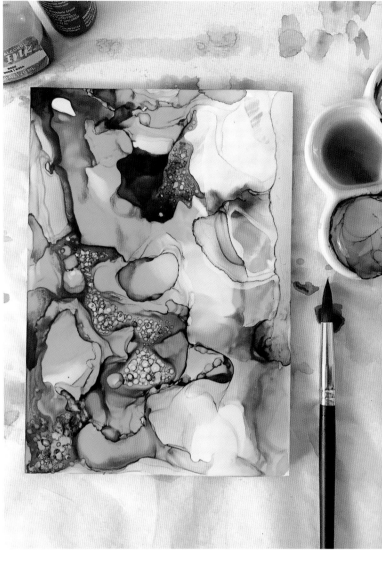

STIPPLING

Stippling is a technique that involves creating small dots to enhance artwork with texture or color. You can vary the size, color, and/or concentration of the dots to achieve different effects in a painting.

Blending Metallic Mixatives

Adding a metallic mixative to your paintings is a beautiful yet simple way to bring a rich quality to your work. This technique can be applied in two ways. The first is mixing the alcohol ink with the mixative before applying to paper, and the other method is applying straight metallic mixative directly on top of an ink wash.

Technique #1: Adding Metallic Mixative to the Entire Painting

This technique creates organic lines and ridges as well as a shimmer throughout the piece. You have less control over where the metallic is placed.

1 Place a clean sheet of Yupo paper on your worktable. Pour about 1 ounce (30 ml) of isopropyl into a small squeeze bottle and drop in equal parts alcohol ink and metallic mixative (about 8 to 10 drops of each). Give it a good shake until you see a gold in the mixture.

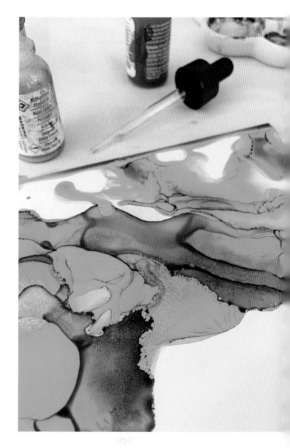

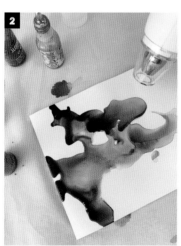

2 Squeeze the metallic alcohol ink mixture onto your Yupo paper and use the heat tool to push the mixture all over the surface. You will see little metallic lines or ridges start to form as the air from the heat tool pushes the metallic particles together. Also notice a pretty shimmer of metallic gold across the entire painting.

Technique #2: Applying Metallic Mixative Directly on the Paper

This technique gives your piece a concentrated buildup of metallic gold in specific spots of your choosing. I like using this technique when I want more control of where the metallic mixative will be placed.

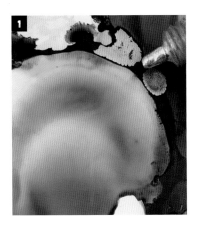

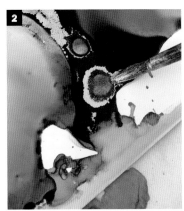

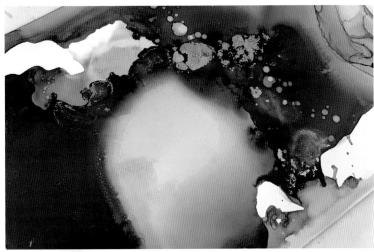

1 Paint a small ink wash on Yupo paper. Use the heat tool to create your wash until the painting is mostly dry; stop when you see little wet beads forming. This is where you will add the gold mixative.

Take the metallic mixative bottle and shake it until you hear the ball inside start to rattle. Squeeze little drops of the mixative from the bottle onto wet sections of the painting. The mixative will react with the ink and isopropyl by swirling, bubbling, and fanning out on the paper.

2 For a little more control, apply the mixative directly to the ink wash with a paintbrush. Place a few drops of metallic mixative into a paint palette well and fill another well with isopropyl. Dip a round brush into the isopropyl, filling the brush about a quarter of the way, and then load your brush fully with the mixative. Apply the brush to wet sections of the ink wash and watch it react with the ink. Try pushing and pulling the mixative with the brush to break it up.

DESIGNATE BRUSHES FOR MIXATIVES

Completely cleaning a brush after using it to apply mixative is almost impossible, so designate one or two brushes for applying mixatives. To clean the brush for future mixative applications, swirl it around in isopropyl and dry with a paper towel.

Spraying

Filling a mister with isopropyl and spraying your painting is an easy way to add texture. I like to use this effect in ocean-inspired pieces because it mimics the spray of crashing waves. This technique is also great for hiding areas of a painting where you've made a mistake—just spray a little mist of isopropyl and completely transform a mistake into gorgeous texture!

1 Create an alcohol ink wash or use a practice piece from a previous technique. I demonstrate this technique using the practice sheet from Technique #2 of blending mixatives (see page 29). Place your ink wash on a protected worktable and fill a mister with isopropyl. Collect a few pieces of scrap paper that are slightly larger than your surface; this will protect areas of the painting that you don't want affected by the isopropyl mist. Place the scrap paper over the area you do not want the mist to touch.

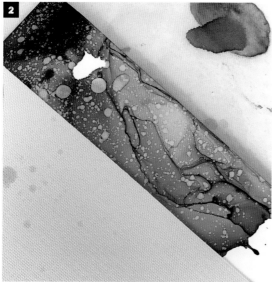

2 Hold the spray bottle about 18" (45 cm) above the painting and apply a light mist (usually a half pump). You will see an array of lively little dots form on the surface.

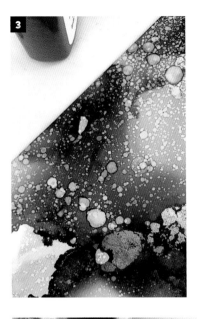

3 Move the mister closer to the paper (about 12" [30.5 cm]) and spray again (a half pump). Keep playing with moving the mister closer and farther away from the paper; as you apply the mist closer to the surface the effect becomes more concentrated and the specks become larger.

4 For a more organic look to the spray pattern, remove the scrap paper and place a gloved hand over the section you don't want the mist to disturb and spray another half pump. This will give you a more organic look instead of the hard edge created by the scrap paper.

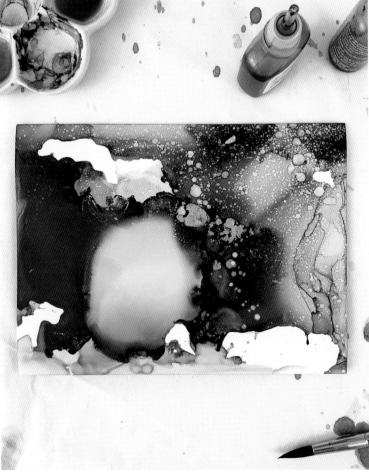

CONTAINING THE BLOOM

As with creating blooms (see page 26), you can blow on the paper after you've applied a mist to stop the spray from blooming or spreading.

Masking

Masking fluid can be used to cover and protect areas of a surface, preserving the white while paint is applied over it. The fluid is then removed to reveal the white surface, which creates a strong contrast with the ink.

Working with a masking fluid pen is one of my favorite techniques. It allows me to easily incorporate geometric designs, organic lines, and even the human form into my alcohol ink paintings, which would be almost impossible to accomplish with a fluid medium in any other way, other than applying an adhesive stencil.

In this demonstration I use ultrasmooth gesso board as a surface, but the technique will work on any surface that takes alcohol ink.

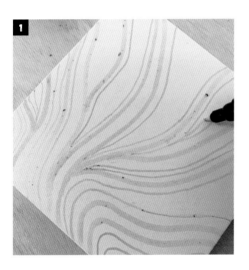

1 To get a masking pen flowing, give it a good shake and pump the nib on scrap paper until you see masking fluid on the tip. Use the masking pen to draw directly on the surface. Create any design you want. It doesn't have to be perfect, and you don't need to re-create the one shown here. Aim for a design that extends over the entire surface so you can get a good feel for the technique as well as how to handle the pen. Once you're happy with the design, let the masking fluid dry completely before continuing with the next step. Masking fluid dries quickly and has a tacky feel to it.

DRAWING WITH MASKING FLUID

If little bits of masking fluid ball up on the nib of your pen, simply pull them off with your fingers and discard them on a paper towel. There might also be little bits of dried fluid on your mask drawing. Don't try to remove them at this point; they'll come off with the rest of the mask when you finish your painting.

It's easy to change your drawing. Let the masking fluid dry, rub off the area you want to remove with your finger, and then reapply.

Create visual interest by using a range of line widths within a piece. To achieve that, I use the Pebeo Drawing Gum High Precision Masking Marker as well as the broad Molotow GRAFX Masking Fluid Pump Marker, which comes in 2 mm and 4 mm nib widths.

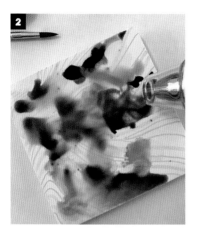

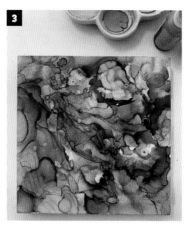

2 Move the masked surface to a protected worktable and paint an alcohol ink wash on top of the mask. I used a heat tool to create some textured drama in the wash, but you can use any air tool you like to push the ink across the surface.

3 Cover the entire surface with alcohol ink so you can see the full effect of the mask. Let dry completely.

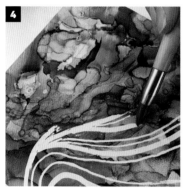

4 Use an eraser tool or a gloved finger to rub off the masking fluid, applying medium pressure as you work. As you peel the mask away, you'll reveal the white surface beneath it. Clean the eraser tool or glove frequently throughout the removal process to avoid transferring ink to the white areas.

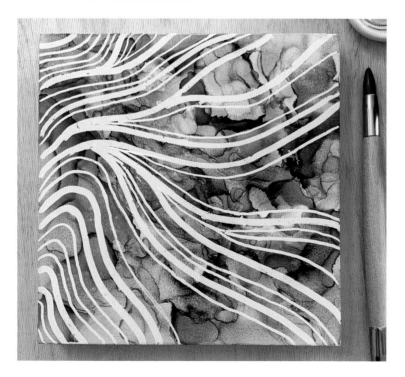

FIXING INK TRANSFERS

If ink accidentally transfers to white areas while you're removing the masking fluid, try these fixes:

- Remove transferred ink with a cotton swab that's been lightly moistened with isopropyl alcohol.
- Paint the affected areas with a paint pen or with white acrylic paint and a small paintbrush.

Lifting

Add dimension and depth to a piece using the lifting technique. Like the name implies, this involves lifting or moving the ink from the original painting to create lighter areas. You can lift with stamps, patterned rollers, cotton swabs, paintbrushes, or anything that will soak up the ink.

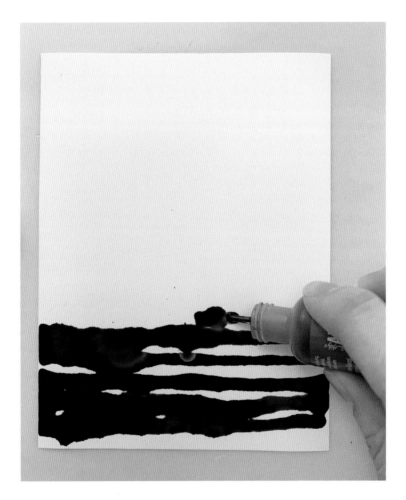

1 Place a blank sheet of Yupo paper on a protected work surface. Directly from the bottle, lay down five alcohol ink colors adjacent to each other. Notice the alcohol ink colors will start to blend together as they move on the paper—don't worry as this is a good thing!

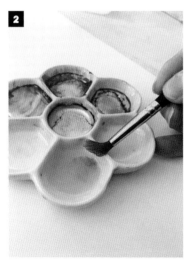

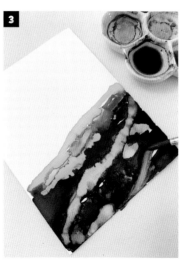

2 After the ink is about halfway dry, take a clean round brush (I'm using a #10) and pour isopropyl into your palette. Fill the brush with isopropyl and tap off the excess into the palette so it isn't dripping off the brush. Be careful not to overfill the brush with isopropyl because it can be difficult to control the application once it starts reacting with the alcohol ink.

3 With the isopropyl-filled paintbrush, follow the alcohol ink lines that formed naturally when you laid down the alcohol ink in step 1. Observe how the isopropyl pushes the alcohol ink to the edges, creating a new lighter line or texture. Repeat this step until you are happy with the result. Go a step further and experiment with mixing isopropyl and alcohol ink in your palette and brushing it on top of the ink wash, using the tip of the brush to create smaller lines.

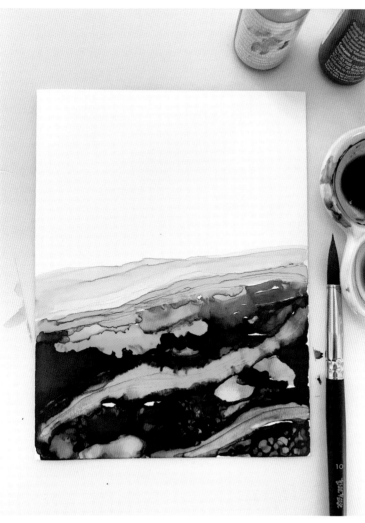

Drawing over Washes

A fun way to add more controlled details or designs to paintings or craft projects is to draw on top of them with paint and gel pens. There are numerous brands to choose from, but my favorite are Uni Posca paint pens and Sakura gel pens.

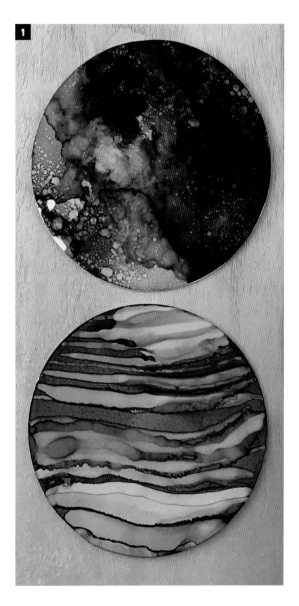

1 For this tutorial, I used Yupo paper that I cut into circles. You can do the same, but any surface or shape will work for this technique. Paint an ink wash on one and on the other use the lifting technique on pages 34–35. Spray one layer of Kamar varnish before you apply paint or gel pens so the alcohol ink wash does not reactivate and damage the pens.

MAKE COPIES OF YOUR ARTWORK FOR EXPERIMENTS

If you want to draw on an original painting but are a little nervous, try scanning the painting and making a few prints, and then practice drawing on the prints before moving on to the original.

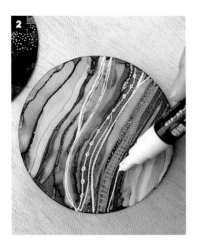

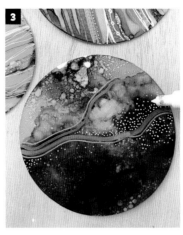

2 When I'm drawing on top of an ink wash, I like to follow the natural lines and textures that were created when I painted the ink wash. In this painting, I used the lifting technique (see pages 34–35), which creates more defined lines, making it simple to follow with the pen. To add interest to the piece, vary line thicknesses, use multiple colors, incorporate stippling (see page 27), or create hard lines. This is where you can get really creative, so just go for it!

3 Next take a basic alcohol ink wash that doesn't have well-defined lines and experiment with drawing random lines or designs over the wash and add a little stippling (see page 27). What I love about this technique is that you can get really creative and fill the entire space with your pen drawings, or you can take a less-is-more approach and just add in little details to create interest in specific areas.

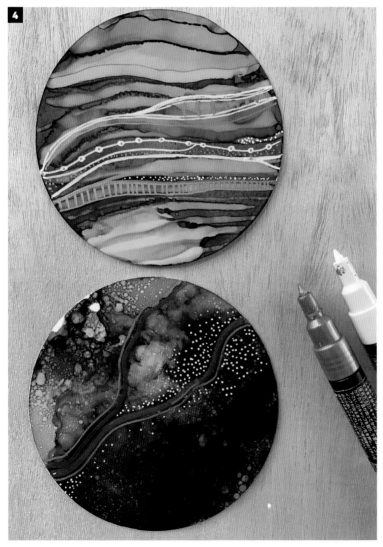

4 Look for natural elements, such as flowers, ocean waves, or landscapes, within your abstract ink washes and outline what you see with your pens. As you train your eye to call out distinct shapes and forms, little speckles transform into a rocky beach or stars in the night sky, ridges become mountain ranges, and dynamic ink flow patterns transform into crashing waves.

Stamping

A popular way to transfer alcohol ink to a porous surface is by using an alcohol ink lift pad with stamps. This technique is often used when creating greeting cards, gift tags, and custom paper products.

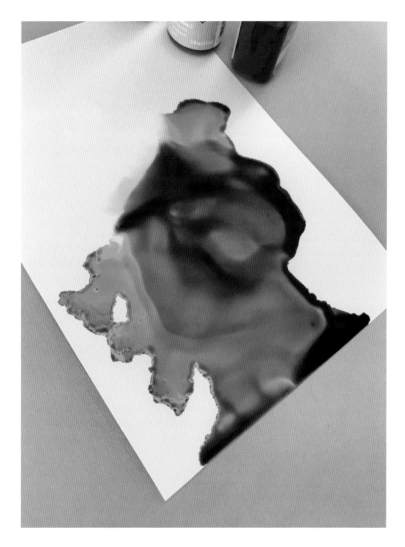

1 Place Yupo paper and card stock on the worktable. Paint a quick ink wash on the Yupo paper using three to five different colors. Don't let the wash dry completely.

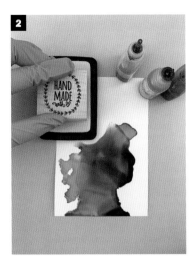

2 Take a stamp and push it into the alcohol ink lifting pad, making sure you get even coverage on the stamp.

3 Press the stamp directly into the alcohol ink wash and offload the excess ink by stamping a piece of scrap card stock—if there is too much ink on the stamp you won't get a clean transfer.

4 Press the stamp onto a clean piece of card stock, creating a crisp transfer.

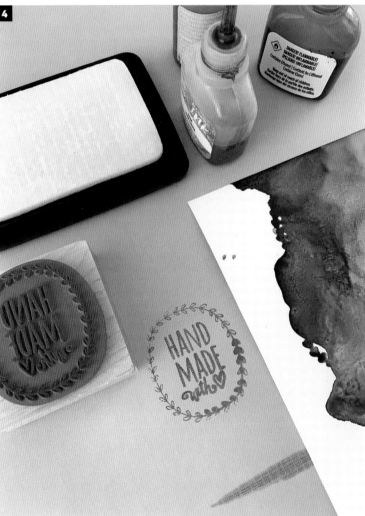

TEST ON SCRAP PAPER FIRST

It's always a good idea to test on scrap paper before working on your final surface. Getting a feel for how stamping with alcohol ink reacts with various surfaces will keep you from potentially ruining the final piece.

Embossing Powder

Adding embossing powder is a simple method that imparts a rich quality to alcohol ink paintings. I use embossing powder to add quotes and shapes; to highlight details and designs over original alcohol ink paintings; and add a little originality to fine art prints.

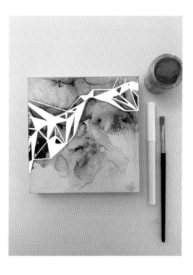

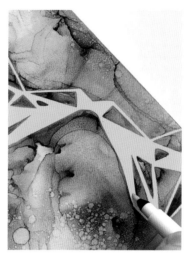

COVERING BARE SPOTS

If you're left with any bare spots or you touch the embossing powder as it's drying, you can apply an additional layer of embossing powder by repeating steps 2 to 5; just make sure the first layer of embossing powder is dry before adding another layer.

1 For this tutorial, I used a painting I created using the masking technique (see page 32) because I wanted to apply embossing powder to the white areas. If you prefer to use a standard ink wash, that also works perfectly with this technique; you can pretty much use embossing powder on any surface! To keep your ink wash from reactivating as you apply embossing powder, spray one layer of varnish on the ink wash and wait until it's dry before moving on to the next step.

2 Take the embossing pen and draw directly on the alcohol ink painting any design or text you prefer. I embossed a few triangles into the negative space of the mask I created. Make sure you get complete coverage with the embossing pen on all parts you want to be embossed so you don't end up with bare spots. You can also use a black embossing pen instead of a clear one so you can see where the pen has been applied.

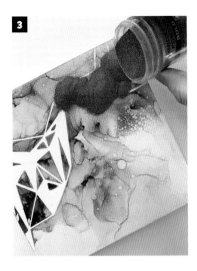

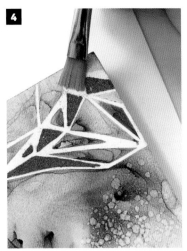

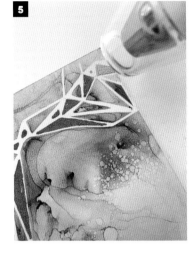

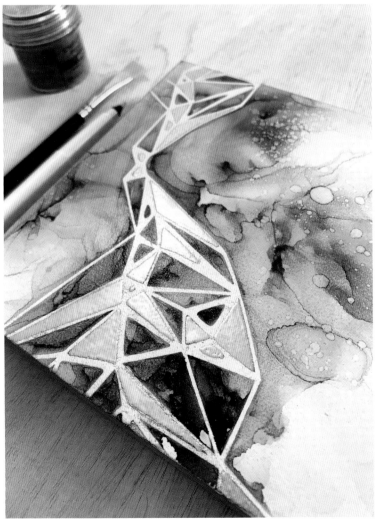

3 Pour embossing powder on top of the embossed pen drawing. Pour nearly the entire bottle to get complete coverage, tap off the excess embossing powder onto a clean sheet of copy paper, and pour it back into its bottle. If you see any bare spots that the embossing powder didn't stick to, try pouring the powder over those spots again. Let dry for 15 minutes.

4 Brush off any excess powder that was left behind on the surface with a stiff brush.

5 Take an embossing gun and apply heat to the embossing powder until it has fully melted. If embossing on Yupo paper, be mindful not to concentrate the heat in one place for too long or the paper will warp and melt. Experiment with how much heat the paper can withstand.

Plastic Wrap

This technique is extremely easy and the results are amazing! It works on any surface that takes alcohol ink.

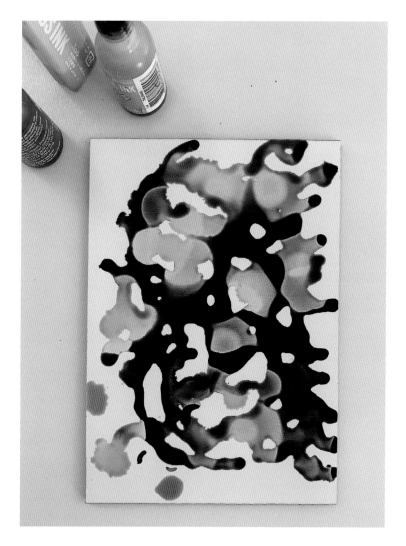

1 Place a substrate on a protected worktable. I am painting on an ⅛" (3 mm)-deep Gessobord. Squeeze directly from the alcohol ink bottle onto the surface in a random fashion, using three to five colors. Pick up the substrate and tilt it in all directions, letting the ink run and blend so it covers the majority of the surface.

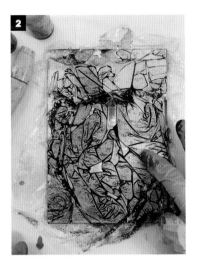

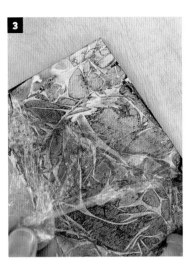

2 While the alcohol ink is still wet, lay down a piece of plastic wrap that's slightly larger than the surface and push it around with your fingers until you're happy with the texture the plastic wrap has created.

3 Let the surface sit for about 24 hours, or until completely dry. Peel off the plastic wrap to reveal the beautiful textures you created with this easy technique! Create an entire project around this technique or add a few areas in your project where you want to add some interest.

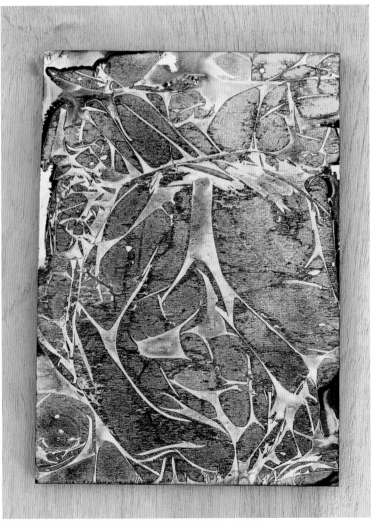

Adhesive Stencils

Adhesive stencils are a simple way to incorporate unique designs into alcohol ink paintings. Because the stencil adheres to the paper, you can keep the ink contained within the stencil with very little bleeding under the surface. Buy ready-made adhesive stencils or create your own by cutting contact paper into custom designs. For this example, I used a store-bought stencil.

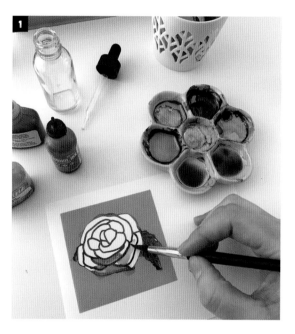
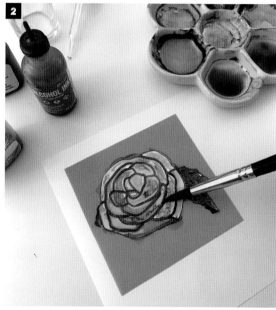

1 Place a clean piece of Yupo paper on a worktable. Remove the adhesive stencil from its backing and press the stencil on the paper, making sure it is secure. For the first ink layer, add about six drops of alcohol ink and three drops of isopropyl to your palette. Fill a round paintbrush with the alcohol ink mixture and start painting the first wash onto the stencil.

2 Layer in as many colors as you like or keep the same color but play with the transparency by applying straight alcohol ink in a couple of places for a more saturated palette, or straight isopropyl to lighten your palette. For a more saturated and vibrant palette, use a more concentrated mix of alcohol ink; for a lighter look, add more isopropyl to the mix. Keep a piece of scratch paper handy so you can test the transparency of your palette.

USE A BRAYER TO ADHERE THE STENCIL

Use a brayer to roll across the surface to help make sure all parts of the stencil have tightly adhered to the paper.

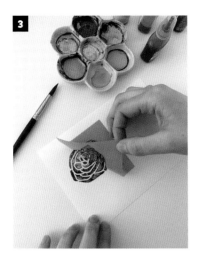

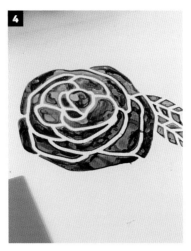

3 While the adhesive stencil is still attached to the paper, incorporate a few of the techniques you learned earlier, such as spraying or stippling. While the alcohol ink is still wet, experiment with a heat tool to create some pretty textures. Be careful not to concentrate the heat tool in one spot for too long or you'll risk melting the stencil and the paper. Once the alcohol ink is dry, carefully remove the stencil from the paper.

4 The results won't always be perfect: You may get really clean and crisp lines, or you might notice bleeding under the stencil. Learn how to turn these little "mistakes" around in your favor, perhaps by using a paint pen to define a few lines or stippling the area that bled to make the bleed look intentional. These adjustments are part of the learning process and a fun challenge. I personally welcome these little "mistakes" because it adds to the originality of my art.

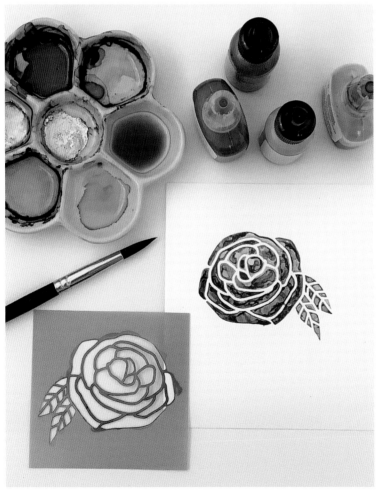

Adding Texture with a Catalyst

A catalyst is a wedge tool made from silicone that's used to spread paint and add texture to paintings. I love using a catalyst to create organic lines and textures.

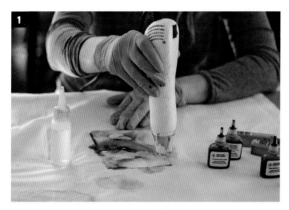

1 Paint an alcohol ink wash on a clean sheet of Yupo paper and let it dry completely. Use a heat tool or your breath to move the ink around the paper.

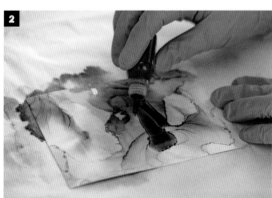

2 In the center of the ink wash, lay down a few alcohol ink colors next to one another and add a few drops of isopropyl on top.

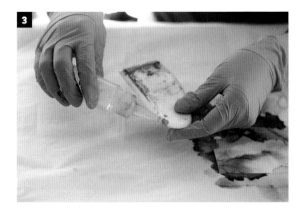

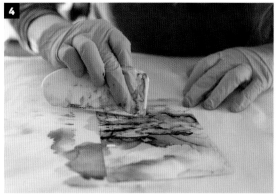

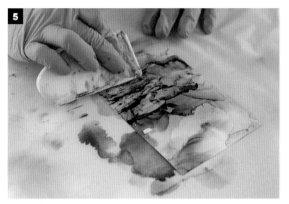

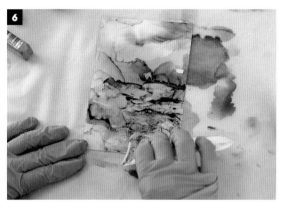

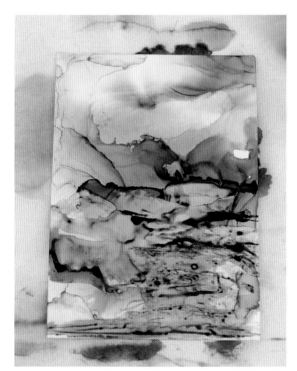

3 Take the catalyst wedge and drop a little isopropyl on its edge and then give it a good tap so the isopropyl isn't beading off.

4 Dab the isopropyl edge of the catalyst into the wet alcohol ink. Note the linear texture it creates. Alternate dabbing into the wet ink wash with the edge and the flat face of the catalyst to create various effects.

5 Use the catalyst as a squeegee and pull the alcohol ink from the middle to the bottom of the paper.

6 As the alcohol ink dries, repeat this technique using the edge and the flat side of the catalyst to see how the effect differs when the alcohol ink is semi-dry rather than dry.

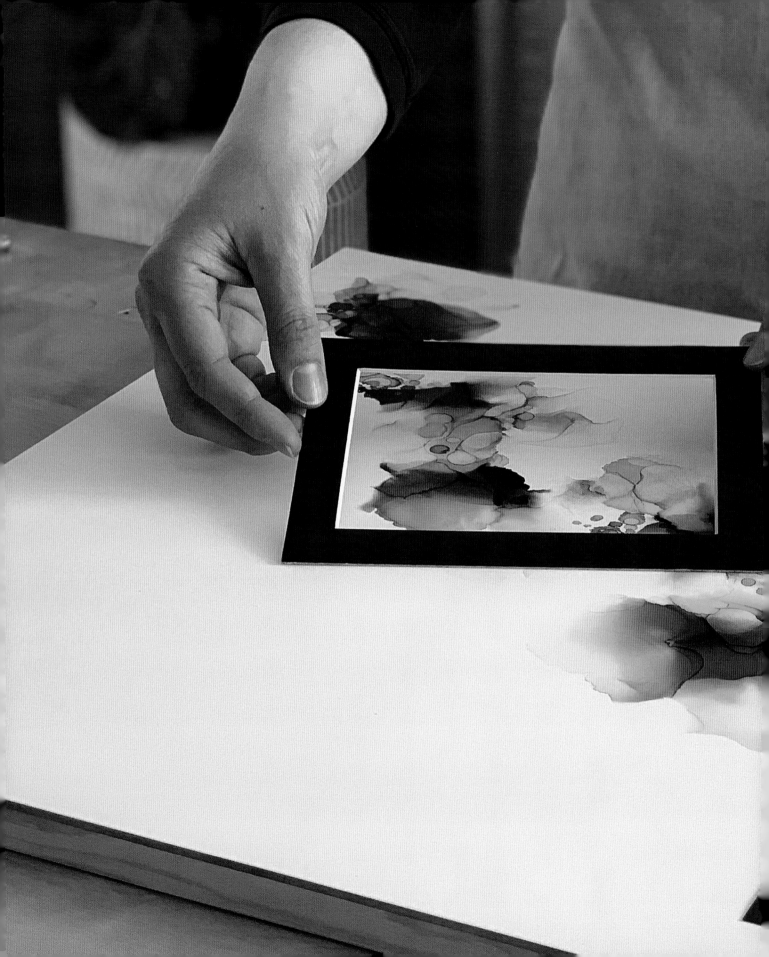

3
Inspiration, Color & Composition

NOW THAT YOU'VE HAD TIME TO PRACTICE the basic techniques of alcohol ink, let's dig into how to create a successful painting by learning how to find inspiration, explore exciting color palettes, and create dynamic compositions.

Finding Inspiration

Inspiration is different for everyone, and learning to find that inspiration and transfer your ideas to paper is an exciting and important part of the process. Inspiration can hit you when you aren't expecting it or it can hide, which can be frustrating. Let's go through a few different ways you can get inspired and how to document your inspiration as part of the process.

Just start painting! Sometimes inspiration is elusive and the best way to find it is to just start painting. Giving yourself the permission to experiment without any expectations puts you in the mind-set to let creativity flow. Often this process will result in unearthing new ideas and inspiration. Start by experimenting with color palettes that you wouldn't usually work with and spontaneously applying them to your surface.

Find things in nature. Getting inspired by nature is another way to discover new ideas. I live in the Pacific Northwest and it's filled with exciting color palettes, dynamic textures, and interesting patterns that I can derive inspiration and fun compositions from. Step outside and really pay attention to the details around you. For example, pick up a rock and notice the color palette or the veins running through it that could create an exciting composition. If you can't get outside, do an internet search for textures and patterns in nature for endless ideas and inspiration.

Become inspired by other artists. Another way to find inspiration is to look at some of your favorite artists. What palettes do they use? What subjects inspire them? Exploring what inspires other artists can help you learn to view thoughts and ideas in a new way than you're accustomed to.

Keep a sketchbook! I live in a constant state of creative chaos and the only way I can keep my inspiration straight and orderly is by keeping a sketchbook to house all my ideas. I keep a few sketchbooks at any given time: a small one that fits in my purse, a medium-size one for my color studies, and a large one where I can incorporate the ideas from my other two sketchbooks in one place for planning a final painting.

Sketch compositions, textures, and color palettes that inspire you; paste pictures that you find in magazines or online; apply pressed flowers or leaves, or just collect anything that inspires you and add it to your sketchbook. Traveling with alcohol ink and having to set up a protected workspace every time you want to put ideas into your sketchbook can be inconvenient, so try using colored pencils or markers to create color palettes in your sketchbook—it doesn't matter what you use as long as it gets your intention across so you can easily translate it to alcohol ink.

USE THE NOTES APP ON YOUR PHONE

In addition to a sketchbook, the "notes" app on my phone has been a lifesaver; when I don't have access to my sketchbook, I type out a quick note that I can look at later.

Color Basics

Color choice is so important, and having the skills and knowledge to know how to blend and select colors will help you create successful and harmonious paintings. Experimenting with different palettes opens the door for you to find your favorites and discover palettes that you dislike—learning both is equally important! Keep notes in a sketchbook of color successes and failures so you have something to reference when planning future paintings. Here are some essential terms to know:

Hue. A shade of color.

Value. Refers to the light or darkness of a color. If the hue is yellow, for example, the value defines whether the hue is light, medium, or dark yellow.

Chroma. The intensity or saturation of a color. If a color appears more vibrant or rich, it has a high chroma. Lower chroma results in a duller color.

Primary colors. Blue, red, and yellow are the three colors from which we create all other colors **(A)**. You can't mix any colors to create primary colors.

Secondary colors. When two primary colors are mixed together, they create a secondary color. Red and yellow make orange, yellow and blue make green, and red and blue make purple **(B)**.

Tertiary colors. When one primary color is mixed with a secondary color, they create a tertiary color. Blue-green, blue-violet, red-violet, red-orange, yellow-green, and yellow-orange are all tertiary colors **(C)**.

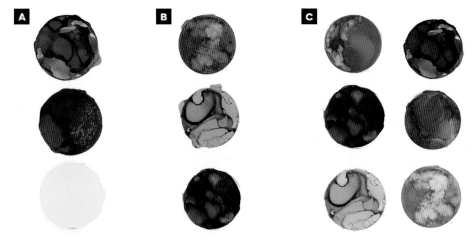

The primary **(A)**, secondary **(B)**, and tertiary colors **(C)**

Creating your own color wheel is a great way to become more familiar and comfortable with your ability to mix colors. Use my color wheel here as a guide. The outer colors are at full saturation—no isopropyl is mixed in. The second colors in are lightened with a little isopropyl, and the center colors are lightened even more with isopropyl, creating a pastel-like color.

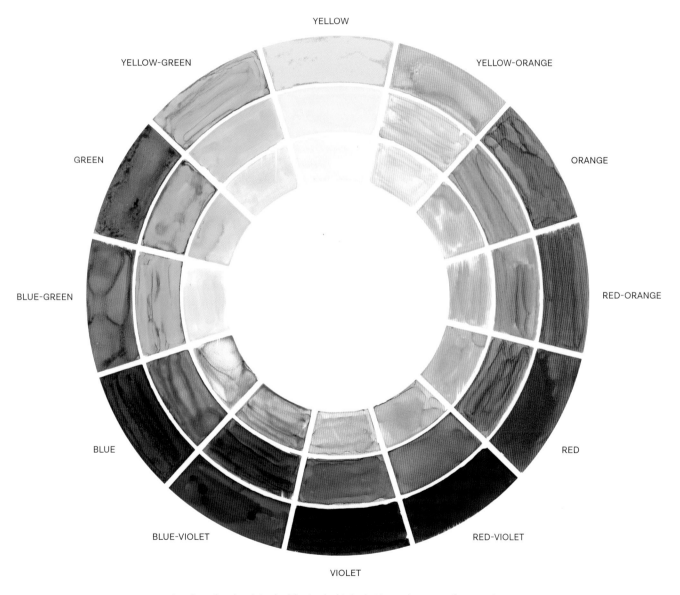

A color wheel painted with alcohol inks in three degrees of saturation

Color Schemes

If you need help finding a color scheme to start your painting, try using one of the popular color wheel–based schemes below and opposite. I also share my favorite color palettes on pages 57 and 58.

Monochromatic. A monochromatic color scheme can be described as all the colors of a single hue. Here I've shown the different values of red to create a monochrome palette. To start, I used red alcohol ink in its most saturated form, straight out of the bottle, and then I gradually applied isopropyl to lower the intensity, working my way down to pink.

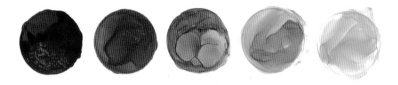

Analogous. Analogous colors are located adjacent to one another on the color wheel. This color scheme is the easiest to create, and analogous colors used together produce a low-contrast but harmonious palette. If you're unsure about which color scheme to start with, I'd recommend analogous colors.

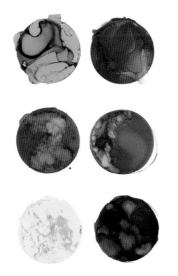

Complementary. Complementary colors are found opposite each other on the color wheel and are a wonderful way to create contrast in your work. When using this color scheme, be mindful that because of their contrast, the colors can compete with one another, which can be visually overwhelming. Experiment with selecting one dominant color and using its complement as an accent. See what your palette looks like when you use equal parts of the complement. Complementary colors are also used to dull or darken each other. For example, if you mix a small amount of blue into its complementary color (orange), you will get a more earthy or dull orange.

Triadic. A triad color scheme is a group of three colors that are spaced evenly around the color wheel. I use the triad scheme the least because it can create an intense color palette with the colors fighting for attention. When painting in a triad scheme, try to select one prominent color and use the other two for accenting, which will help balance the palette.

Split-complementary. You can easily create a harmonious color palette using the split-complementary color scheme. For example, select two complementary colors, such as blue and orange. Keep the blue as your base, but instead of using the orange, use the two colors found on either side of orange, which are yellow-orange and red-orange.

Color Studies

One of the most exciting parts of the process is discovering new color stories—some days, that's all I do in the studio! It's also important because color is where you can translate an emotion or jump-start inspiration. If I'm struggling with finding inspiration, I'll often explore different palettes. Usually a color palette will start to evolve and that will spark a new vision for my next piece.

Experimenting with different color palettes is helpful in that you learn how the alcohol inks react and blend with one another. One of the fascinating parts of working with alcohol ink are the color variations that can be found in just one color. For example, if I apply this gray to Yupo paper, add isopropyl, and spread the mixture around the surface, blue, pink, and orange will emerge, as in the image to the left—and this effect is from just one color!

To get you started in the process, I've shared a few of my favorite color palettes opposite and on page 58, and I encourage you to play with them and create your own. Try mixing just two of the colors in my suggested palettes on Yupo paper and see what you can create, and then gradually add more colors and observe how they react to and blend with one another. Add isopropyl to lighten some areas, and add more alcohol ink to darken or increase the intensity.

Experiment with palettes using the color basics on page 52. Try painting with an analogous or a complementary palette and keep notes of what you observe.

Record your color study successes and failures in a sketchbook to keep track of the palettes you've explored. At this time, there aren't any alcohol ink–specific sketchbooks on the market, so I improvised and purchased a standard art journal and used a glue stick to adhere Yupo paper directly into the journal. Seal your color studies using the instructions on page 64 so they don't stick to the opposite pages.

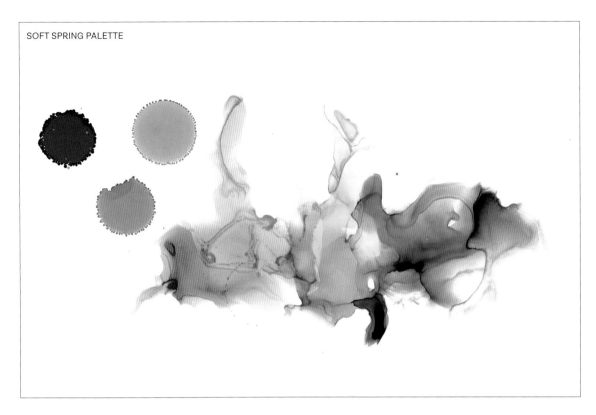

SOFT SPRING PALETTE

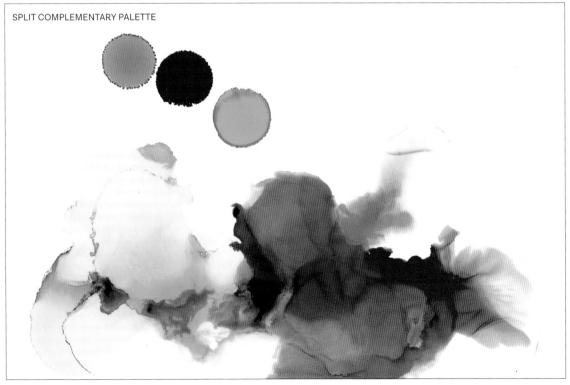

SPLIT COMPLEMENTARY PALETTE

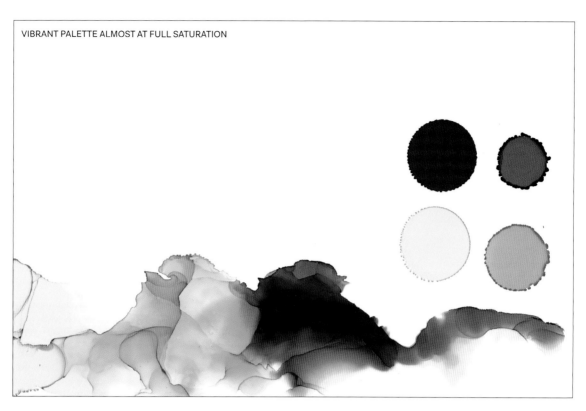

VIBRANT PALETTE ALMOST AT FULL SATURATION

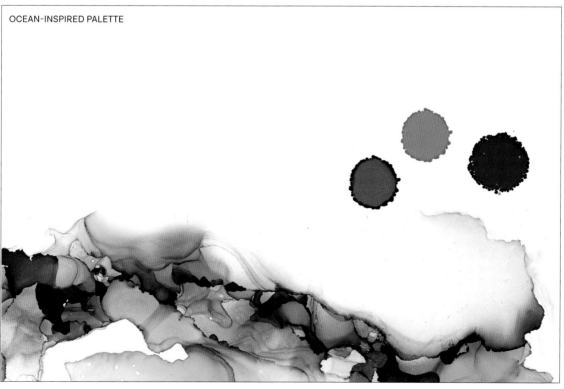

OCEAN-INSPIRED PALETTE

Creating Compositions

Creating a strong composition is essential to the process and success of a painting. Along with color and texture, I tend to lean on negative space to create balance and harmony in my pieces. Negative space is simply the space around the subject and is equally as important when planning a winning composition. Negative space adds emphasis to the subject and provides a place for your eyes to rest within the composition. With alcohol ink, you have the ability to create really dynamic color palettes that are rich in texture and movement, which makes the use of negative space so important. Otherwise your canvas can become "loud" quickly. Being mindful of how you want to use negative space to balance out these attributes will help in creating an engaging composition. Starting below and on the following page are a few examples of how I used negative space to create balance.

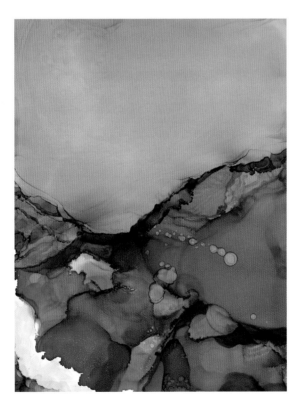

Using negative space doesn't necessarily mean that a painting has to be largely made up of white space. It can include a light ink wash that gives a place for your eye to rest and lead you to the subject.

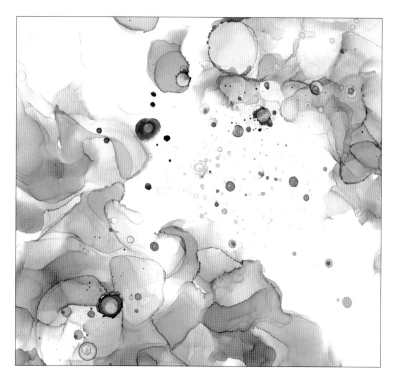

Imagine that this painting was void of white space and the coral-pink filled the canvas. The painting would almost feel as if it were fighting itself for attention and the viewer wouldn't know where to look. Using the white area to break up all the texture and bridging the gap with the dots adds balance, unity, and breathing room to this painting.

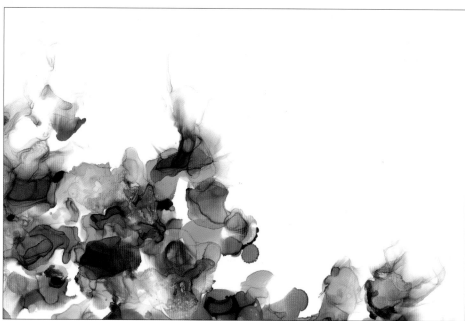

This piece demonstrates how the stark contrast of negative space is used to emphasize the texture and color of the subject. If this particular painting filled the paper, it could end up lacking interest and become overwhelming to the viewer because of the intensity of the color, movement, and texture.

The Placement of the Subject

Really try to think about where you want to place the subject on your paper and how you want it to flow. Before I lay alcohol ink on a surface, I sketch a few compositions in my sketchbook to get a look and feel of the flow. I also find it helpful to map out those ideas with isopropyl on my final surface; this process helps me visualize the composition. It's absolutely okay to start with a composition in mind and veer from it during the process: fluid art is unpredictable, and most of the time you will have to redirect yourself and follow the medium. Learning to manipulate the alcohol ink in this process will help you create lovely compositions even when the alcohol ink has decided to go in another direction.

A helpful way to discover new compositions is by using a viewfinder to focus in on different areas of your painting and re-creating those compositions in future paintings. To create a viewfinder, use card stock and cut a square or rectangle to your preferred size and then cut out the center. To easily reference the compositions, take a quick picture of the compositions that you discovered using the viewfinder and upload them to a file on your computer, or print them out and place in a sketchbook.

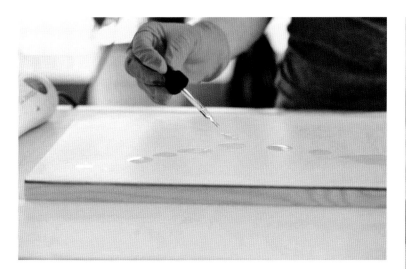

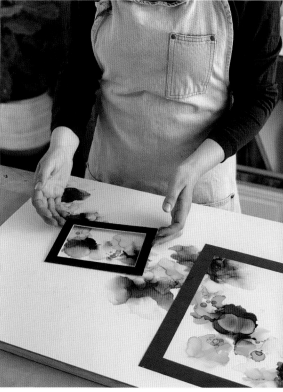

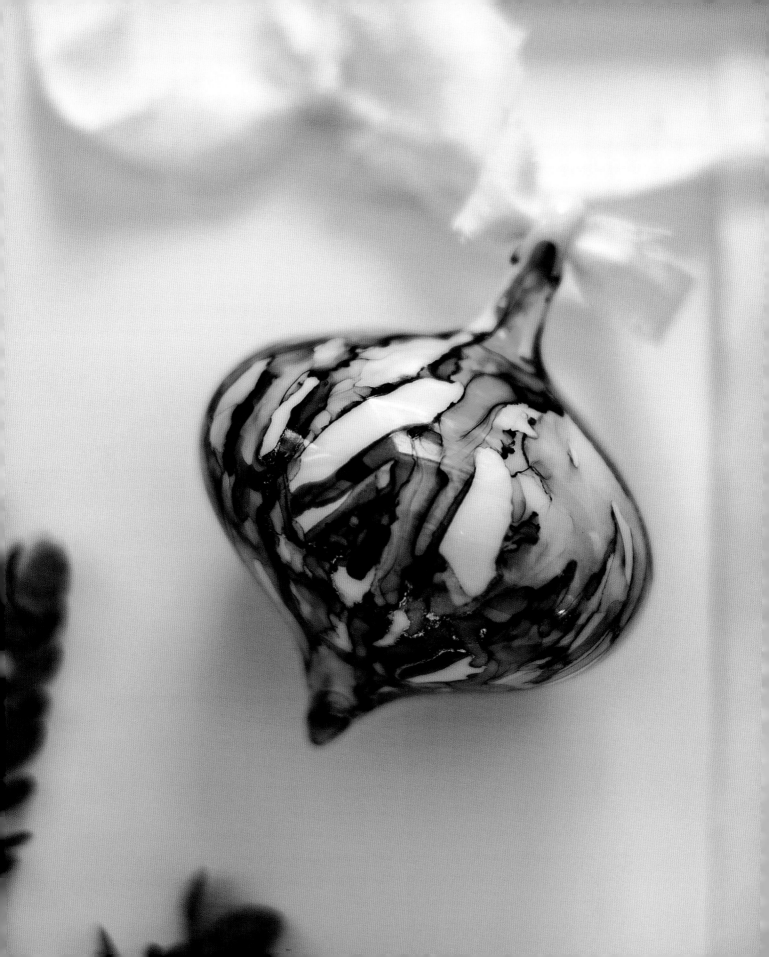

4

Finishing Techniques

AFTER YOU'VE CREATED some amazing new pieces with alcohol ink, let's learn how to keep them safe for years to come! We'll go through the sealing process, how to apply resin, how to create and catalog fine art prints, and framing options.

Sealing Your Work

Sealing artwork is an essential step to protecting it from fading and reactivating the alcohol ink. Following these sealing directions will help ensure the quality and life of your paintings. You will need to work in a well-ventilated space during the sealing process, such as a garage where you can open the bay door, or outside.

WHAT YOU'LL NEED

Canned air or an air tool to remove dust

Protected worktable

Kamar varnish spray

Box, plastic bin, or foam core with 4 cups

UV-resistant matte spray

Clear bag protector

Triple coat spray (for porcelain)

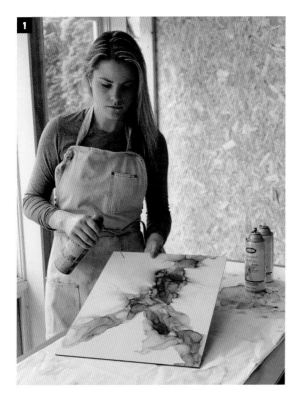

Sealing Paintings

1 Remove any dust particles that have landed on your painting, because whatever you don't remove will become sealed to the painting. Spray canned air over the entire painting to get rid of any dust.

2 To apply the first layer of varnish, lay the painting on a clean and protected worktable and shake the varnish spray vigorously, typically for about 30 seconds. Place your hand about 12" (30.5 cm) above the painting and, in one continuous sweeping motion, spray a light, even coat of varnish from right to left all the way down the painting. To protect the painting from dust while it's drying, place four paper cups around the painting and lay a piece of foam core on top of the cups; a box or plastic bin will work too—just make sure to remove any dust from the cover before placing it over the painting. Wait 15 minutes or until dry to the touch and spray another layer of varnish in an up-and-down motion, and cover again. Wait another 15 minutes or until dry and spray the last layer of varnish from right to left; cover.

3 Because alcohol inks are not lightfast, adding a couple layers of UV-resistant sealant will help protect against fading. When the varnish from step 2 is completely dry, vigorously shake the UV-resistant spray for about 30 seconds and again hold your arm about 12" (30.5 cm) above the painting and spray from left to right in a continuous sweeping motion. Again, cover the painting to protect from dust, wait 15 minutes, and apply another layer. You may notice a light white dust if you touch the painting after the UV protector has dried; this is normal. Immediately place the painting in a plastic protector until it is ready to be framed so it doesn't collect dust.

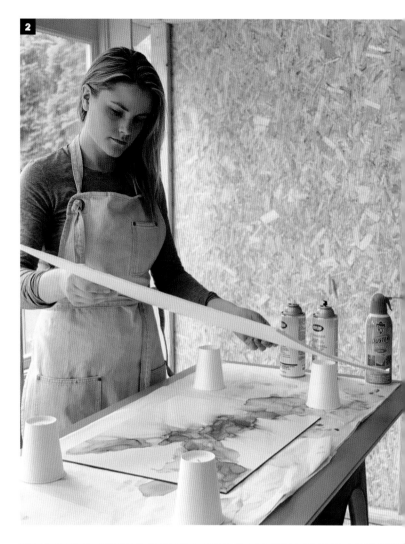

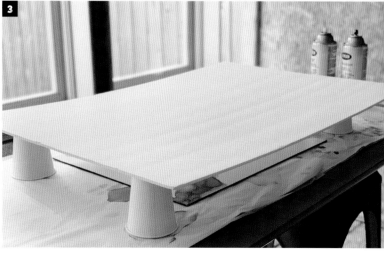

Sealing Porcelain Ornaments

In addition to applying varnish and a UV protector to a porcelain ornament, you will also need to apply a couple layers of triple coat for an extra level of protection.

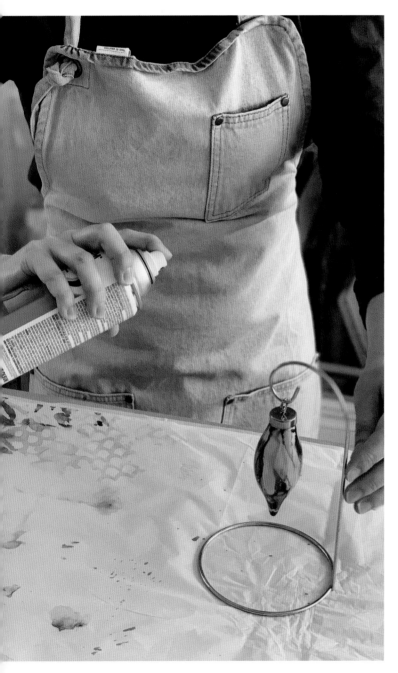

1 First use canned air to remove any dust on the ornament. Hang the ornament on an ornament hanger or anything that suspends the ornament and that you don't mind getting varnish on. Apply three thin coats of spray varnish, making sure to get an even application all around the ornament; wait 15 minutes between each varnish application and cover with a box while it dries. To apply the UV protector, repeat the same varnish application technique but this time using a spray UV protector. Apply three coats, again waiting 15 minutes between each application and making sure to cover with a box.

2 Once the ornament is dry, shake the triple coat spray vigorously for about a minute. With the ornament suspended on the hanger, apply a light and even coat to the bottom, sides, and top of the ornament. Place a clean box over the top to prevent dust from settling on the ornament. Wait 24 hours or until the triple coat is no longer tacky to the touch and apply one more coat. Wait another 24 hours or until it is completely set before using. Note: I've had instances where the triple coat sealant took almost seven days to cure before I could apply a second coat. Typically this happens if humidity is high. If this occurs, keep the ornament covered and try to leave it alone while it cures; if you handle the ornament while it's still tacky, you will leave fingerprints.

Mounting Yupo Paper to Board

Mounting alcohol ink paintings to board is a simple process that adds support and gives paintings a finished look. This also gives you the option to use a float frame, or you can wire the back of the board and use as is to display on the wall. Cradled board is available in a variety of depths, and you can easily find the standard sizes of ¾ inch and 1½ and 2 inches (2 cm, 3.8 cm, and 5 cm) at most art stores. I'm using a ¾-inch (2 cm) cradled board for this tutorial.

WHAT YOU'LL NEED

Unfinished cradled board

220-grit or fine sandpaper

Damp paper towel

Craft knife, such as X-Acto

Heavy matte gel medium

Stiff paintbrush, 1½" to 2½" (3.8 cm to 6.3 cm)

Paper towel or paper that is slightly larger than the cradled board

Brayer

Cutting mat

1 After the alcohol ink painting on paper is sealed using the sealing process on page 64, start the mounting process. Place all your supplies on a protected work-table. Give the cradled board a light sanding to remove any fibers or bumps and clean off with a damp paper towel.

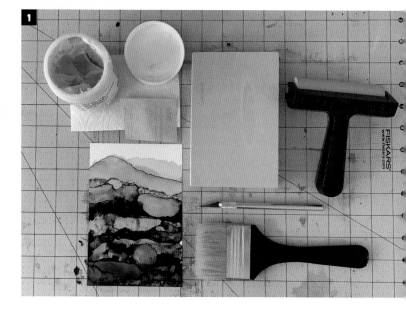

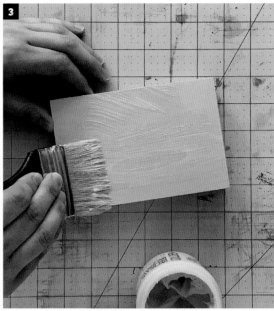

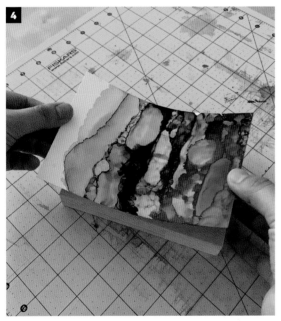

2 Using a craft knife, cut the painting so that it's slightly larger than the board, leaving at least ⅛" (3 mm) over-hang. Having an overhang allows you to easily place the painting on the board without worrying about lining up all the sides perfectly. We'll cut off the excess later after it has dried.

3 Apply the heavy matte gel with a stiff paintbrush to the surface of the board, painting it on in one direction, and then apply more, painting in the opposite direc-tion for a good application. Really focus on the edges to make sure you get a tight bond; you don't want the painting peeling up because there wasn't enough adhe-sive. The board absorbs the gel at a fast rate, so work quickly when applying. (Clean your brush off right away with soap and warm water!)

4 Place the painting on top of the board. Start by bowing the paper in the middle and laying it down in the center of the board, smoothing out one side and adjusting the position as you go, and then laying down the other side in the same fashion, smoothing out bubbles as you go and pressing down to bond the paper to the board. While the gel is still wet, push the painting around on the surface of the board to position it.

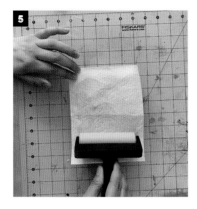

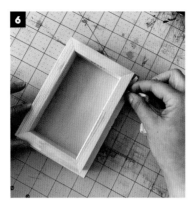

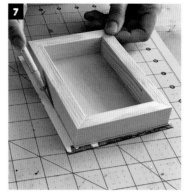

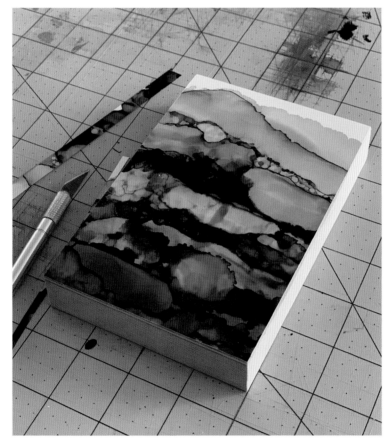

5 Once you're happy with the position of the painting on the board, take a paper towel that's slightly larger than your painting and place it on top. Take a brayer and roll over the top of the paper towel from the center out to the edges. This will help the paper bond well to the board.

6 Flip the painting facedown on a clean surface. Take a damp paper towel and run it along the bottom edge to clean up any gel that's dribbled during the braying process. Keep your painting facedown and apply pressure to the back by stacking large books or something heavy on top for about 24 hours.

7 Once the glue is fully dry, place the painting facedown on a clean cutting mat and carefully cut away the excess paper with a craft knife. You now have a lovely finished piece that you can display as is on a wall, place in a float frame, or cover with resin (see page 70) to really make it pop!

Applying Resin

Sometimes you'll want to apply resin to a finished project. Use a high-quality resin so your pieces don't yellow over time. I use the brand ArtResin, but there are other high-quality brands to choose from. Make sure you do your research when selecting a resin because it's so disappointing when something you worked so hard on turns yellow! Because resin can be finicky, I recommend practicing on a few test pieces before applying it to a final piece. This will help you get a feel for the process and gives you the chance to troubleshoot on a piece you don't care about.

Applying Resin to Coasters

Coasters in particular require a protective layer of resin because they're used on a daily basis.

WHAT YOU'LL NEED

Plastic tablecloth or garbage bags

Level

Painter's tape

Plastic cups to raise the coasters

Nitrile gloves

Resin

Plastic measuring cups

Plastic mixing bowl

Craft sticks

Butane or culinary torch

Toothpicks

Box to place over the resin coasters

Adhesive cork circles

Safety supplies from page 20

1 First, seal the coasters using the sealing process on page 70. Working in a warm space helps keep the resin mixture at a nice consistency and makes it easier to work with. I try to keep the temperature around 72°F (22°C). Set up your workspace in a well-ventilated area with a plastic tablecloth, or lay down garbage bags on a level table. A level table is very important! If the table isn't level, the resin won't be level either. Place painter's tape on the edges of all sides along the bottom of each coaster to protect against resin drips sticking to the underside.

2 Place the cups on the table and center the coasters on top.

3 Measuring and mixing resin are important: If you measure wrong, or the resin and hardener aren't mixed thoroughly, the resin won't cure properly and you'll need to start over. To calculate the amount of resin you'll need, follow the manufacturer's instructions. I refer to the resin calculator on ArtResin.com, which is the brand I typically use. Mix a little more than you actually need just in case you accidentally pour more than intended on one or two coasters. This way, you don't have to stop and take the time to mix more resin. Use about ½ ounce (15 ml) of the resin mixture per 4" (10 cm) coaster and aim for a layer that's about ⅛" (3.2 mm) thick.

The resin mixture is one part resin and one part hardener. Put your gloves on and carefully measure 1 ounce (30 ml) of resin and 1 ounce (30 ml) of hardener. Pour both into a plastic cup or bowl. Use a craft stick to thoroughly mix for 3 minutes, scraping resin from the sides and bottom as you go. Small bubbles will form throughout the resin mixture; you'll pop them later, either with a torch or an embossing heat tool.

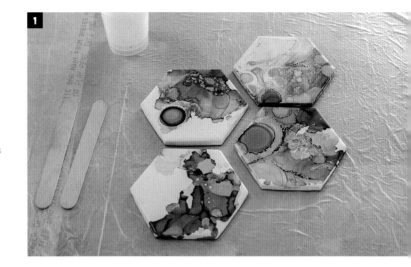

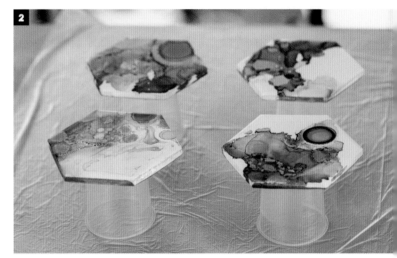

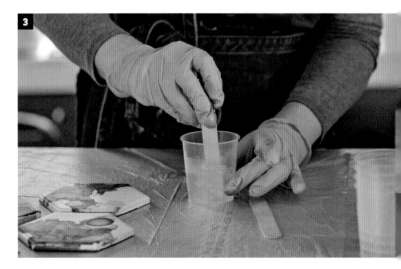

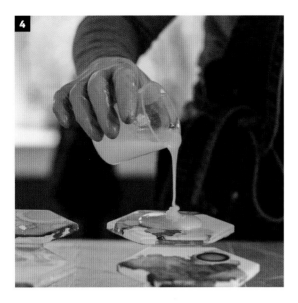

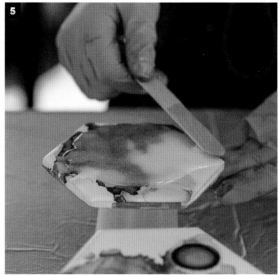

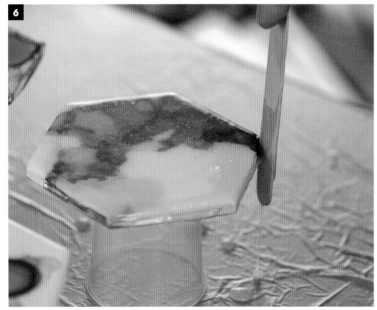

4 Right before you pour the resin, dust off the coasters in another room where you aren't pouring resin so you don't stir up dust, and place them back on the cups. Pour the resin mixture on the center of one coaster.

5 Use a craft stick to spread the resin evenly to the edges.

6 If you have a level table, the resin drips will be minimal, but you can wipe the sides with your fingers or craft stick to help remove drips. Repeat steps 4-6 on all the coasters.

7 Pop any little bubbles that have formed in the resin. To do this, use a culinary torch or something similar. If you're uncomfortable using a torch, use an embossing heat tool

instead. Before using a torch, carefully read the safety precautions associated with the product. Turn on the torch in a very well-ventilated space, hold the flame about 6" (15 cm) above the coaster, and move the torch constantly, trying not to concentrate the heat in one spot or it will start smoking and cause a strange swirling texture when it dries. Please read the safety precautions on pages 20–21 and all manufacturer labels before using a torch.

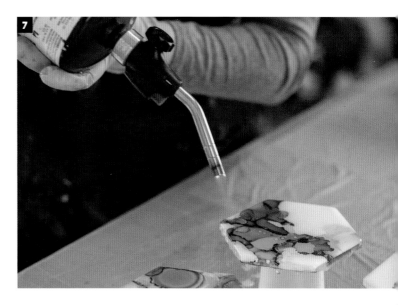

8 Once you've popped the bubbles, take a good look at the surface from different angles. If you see dust, take a toothpick and with the tip pull out any dust particles that have settled on the surface. Place a clean box or bin over the coasters and let set for 24 to 48 hours before removing the box to check on the pieces. Once the resin is fully cured, remove the painter's tape and stick the adhesive cork to the back. If you see cured resin drips on the bottom of the coaster, you can remove them with an electric sander or Dremel tool. Hand wash the top of the coasters with a wet cloth. Because of the cork backing, do not put in the dishwasher or submerge in water.

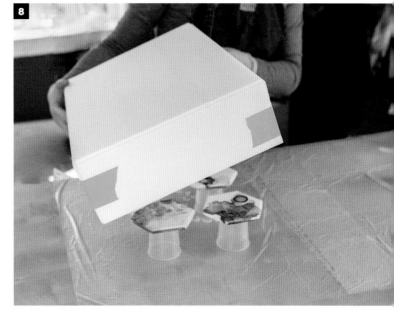

BLEMISHES IN THE RESIN

Sometimes the first (or even second) coat of resin turns up with a stray hair, bubbles, or dust. To remove the blemish, use 80-grit sandpaper or an electric sander and sand until you've removed the hair, bubble, or dust. It may look like you're ruining your piece as you sand, but don't worry—as long as you don't sand down to the painted level, the second coat of resin will fill the scratches and they'll disappear. Sand the entire piece so the resin has a rough surface to adhere to. After you're finished, repeat steps 2 through 7 to apply a second layer of resin.

Applying Resin to Fine Art

Applying resin to a fine art painting is the same process as applying resin to coasters. The only difference is you will tape the sides of the painting to protect from drips. Resin is not required on a fine art painting, but it does add another level of protection and it really makes the colors in the painting pop.

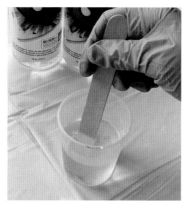

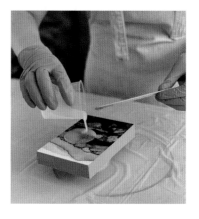

1 Seal your painting using the instructions on page 64. The surface will need a strong foundation to hold the resin, so if the painting is on paper, mount it to a cradled board (see page 67). Tape all four sides with painter's tape. Be sure to get a tight bond so resin doesn't leak under the tape. However, if it does leak under, you can sand it off after it has cured.

2 Protect a level worktable with plastic bags or a plastic tablecloth and put on a pair of nitrile gloves. Keep the space warm, around 72°F (22°C), to keep the resin at a nice fluid consistency. Carefully measure equal parts resin and hardener into a plastic bowl or cup. I use plastic measuring cups to blend the resin mixture. The painting in the tutorial is 4" × 6" (10 × 15 cm), so I'll use ½ ounce (15 ml) of resin and ½ ounce (15 ml) of hardener. Thoroughly mix the two together with a craft stick for 3 minutes, scraping the sides and bottom as you stir. Note: If you need help calculating how much resin to mix, follow the manufacturer's guidelines. (I refer to the resin calculator on ArtResin.com, which is the brand I usually use.)

3 Raise the painting off the table with a cup or something similar so the drips fall onto the plastic bag and don't collect at the bottom of the painting. Dust off the painting in another room and not where you are pouring so you don't stir up dust in the air and have it fall back onto the painting. Pour the resin mixture on the center of the painting.

CAUTION

Before you start, review the safety precaustions on page 20.

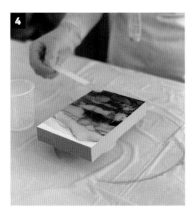

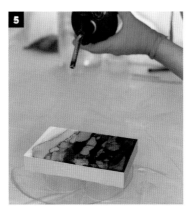

4 Spread the resin out to the edges with a craft stick. You have about 45 minutes to work with the resin before it starts to set.

5 You may notice little bubbles in the resin; either pop them with a torch, as shown, or use an embossing heat tool, which will take longer. If you use a torch, please read the safety precautions associated with it before use. Turn on the torch and with the flame about 6" (15 cm) away from the resin, move the torch in a continuous sweeping motion from top to bottom. Do not concentrate the flame in one place or the resin will burn and cause yellow patches or a swirling texture.

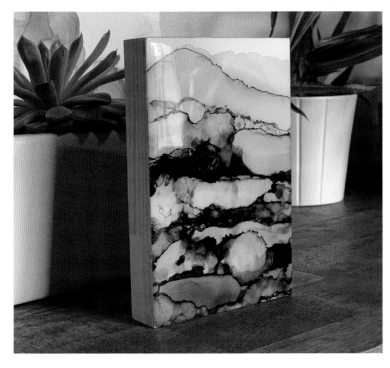

6 Check the resin for any stray hairs or dust that may have settled on the top and pull out with a toothpick. Cover the painting with a dust-free box or bin and let it cure for 48 hours before removing the box. After it's cured, remove the box and look over the painting to make sure there isn't any trapped hair, dust, or bubbles. If you do see anything trapped in the resin, you can sand it out with 80-grit sandpaper being careful not to sand down to the painted surface and repeat the resin process. Don't worry about scratching the resin surface with sandpaper, because once you pour resin on top, all the scratches completely disappear! When applying a second layer of resin, remember to sand the entire piece so the resin has a rough surface to adhere to.

Options for Framing

Protect your alcohol ink painting by finishing it off with a frame to keep dust and oil from settling on the painting. A standard frame works for alcohol ink paintings on paper and float frames add extra support to the framework of paintings on cradled boards.

Standard Frames

Standard frames are the easiest to assemble and the most accessible. You can purchase ready-made frames or order custom frames from a local frame shop. Because alcohol ink is not lightfast, I recommend purchasing UV-protection glass to help prevent fading. Custom frames are expensive, but you can buy a ready-made frame off the shelf and purchase just the UV-resistant glass from a local print shop to cut down on costs.

A mat is a good way to add extra protection to your painting, because the mat keeps the painting from direct contact with the glass, keeping it from sticking to the glass over time.

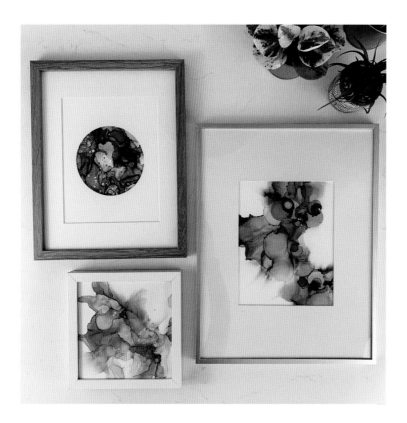

Float Frames

In addition to standard frames, float frames are a unique way to display your paintings and give them more of a modern look and feel. Float frames work with paintings that are on cradled board or paper paintings mounted to cradled board. Float frames leave a small space around the painting to give the illusion that it's floating inside the frame.

Float frames also add depth to paintings, making them appear more substantial. I typically paint on a ¾-inch (2 cm)-thick board and use a 1½-inch (3.8 cm) thick float frame. You'll see a ledge inside the frame that sets the ¾-inch (2 cm) board higher inside the frame to create the impression that the painting was painted on a thicker board.

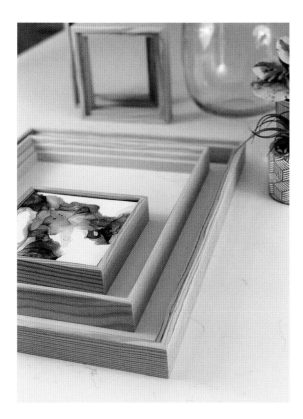
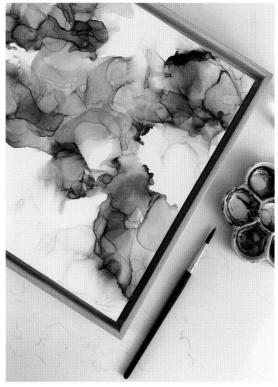

Creating Fine Art Prints

I keep a digital file of all my artwork that goes out of my studio so I have the option to create fine art prints, license my artwork, and add to my portfolio. Cataloging your work is such an important step. There have been times when I almost skipped this step due to being busy and was later relieved I hadn't because a company wanted to license that one piece! Even if your goal isn't to license your art, it's great to be able to utilize something you already created in another form, such as greeting cards, scrapbook paper, or mounting your fine art print to a cradled board and adding a coat of resin. Here I walk you through the process of creating fine art reproductions.

Step 1: Seal. The first step is to seal your artwork using the instructions on page 64. Once sealed, remove any dust that settled on the surface with canned air so it doesn't show up in the scan. Place in a protective clear art bag until you are ready to scan.

Step 2: Scan. I prefer to take my paintings to a local print and copy center to have them scanned; it has a larger scanning bed than my studio scanner, and the color typically turns out very close to the original. I scan my art at 600 dpi, which gives me the option to create large-scale prints double the size of the original and not lose quality. You can scan your painting at 300 dpi, but the reproductions can only be printed at the size of the original painting or smaller. Right before scanning, check your painting for dust once again. Have the copy center save the scanned files to a thumb drive in your preferred format; I like to have my scans saved as a jpg.

Step 3: Check quality. Open the scanned files on your computer; to check the quality, zoom in and look for dust that might have stuck to the painting and transferred to the digital file. If you do find dust on the scan that you can't live with, you can clean it off and scan it again. Sometimes the dust particle is small enough that it won't show up on a print, and I'll choose not to rescan.

Step 4: Make a test print. Next order a test print to check for flaws or color differences. I test all my prints at a local one-hour print center. This is inexpensive, and I can quickly tell whether a print is ready to be sent to a fine art printer. Always test your prints at the largest size available so you can test the quality along with the color. If you're happy with the test print at the largest print size, then there's no need to test the quality of a smaller print of the same piece.

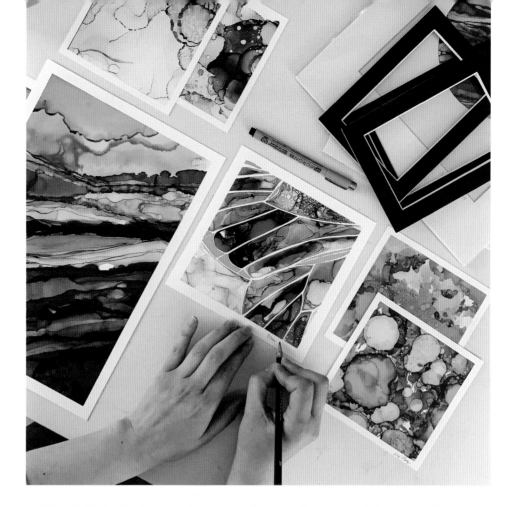

Step 5: Make final prints. You can order your fine art print from an online or a local print shop that specializes in high-quality prints. I find it convenient to upload my scans to an online fine art print company and have them shipped to my studio. You can also research print shops in your area if you'd rather have them printed locally.

There are many paper options to choose from, and one isn't really better than another. I use an array of paper types depending on the effect I want to achieve. A matte paper will give the print a smooth, nonglossy look, a light textured paper tends to have a high-quality feel, and glossy paper can really make the colors pop. Ask your print shop whether they can give you a sample pack of the various papers they carry. It helps when selecting a paper if you're able to touch and feel it. If your printer has the option of adding a white border around the print, this is the perfect place to date and sign your piece.

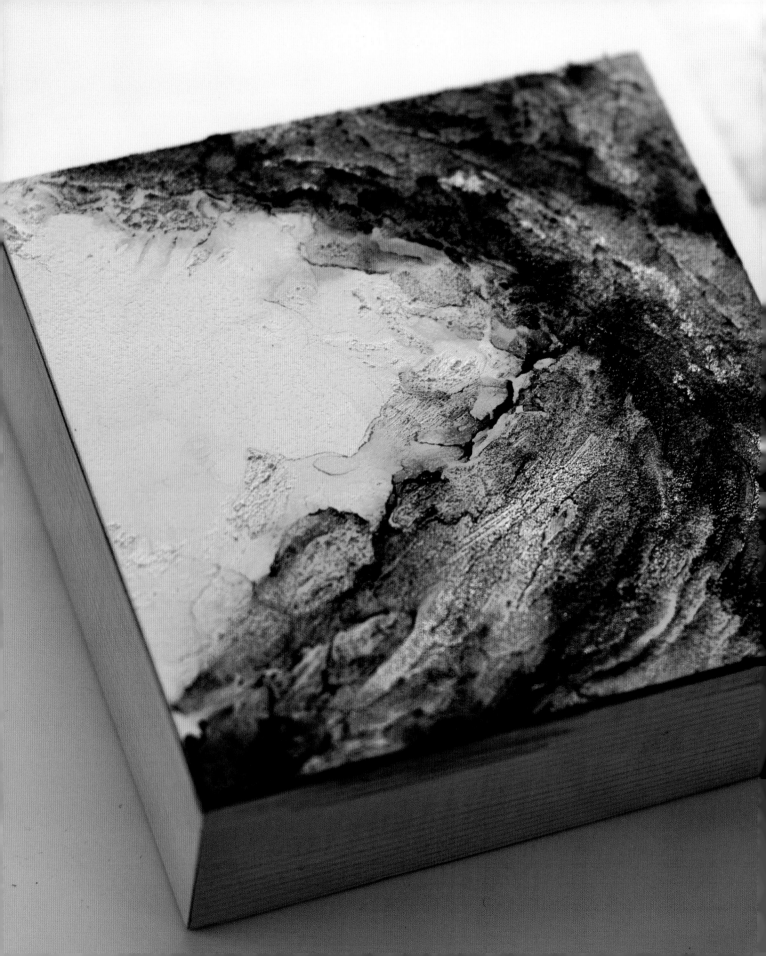

5

Alcohol Ink Projects

NOW THAT YOU'VE PRACTICED the basic alcohol ink techniques, it's time to apply them to some lovely projects! I've selected projects that range from fine art to functional art. Try incorporating the basic techniques to enhance your projects. Be aware of places in your work that you can apply varied textures and interesting color palettes to make your pieces stand out. Remember, alcohol ink is a fluid medium, so try to be flexible during the creative process.

Alcohol Ink Painting on Yupo

Understanding how to create a basic alcohol ink painting is the foundation for all the other projects in this book. I recommend taking the time to create multiple alcohol ink paintings before moving on to the other projects. Learning the basics is so important to the success of your paintings and/or craft projects. You need to understand how the alcohol ink moves and experiment with the techniques at this stage to catapult you into the projects that follow with ease. In this project, we incorporate basic alcohol ink washes, spraying, and blooming techniques, which are covered in Chapter 2 (see page 23).

WHAT YOU'LL NEED

Yupo paper, 9" × 12" (23 × 30.5 cm)

91% isopropyl or blending solution in a craft bottle

Alcohol ink

Air tool (hair dryer or embossing heat tool preferred)

Spray/mister

Round paintbrush

Palette (optional)

Safety supplies from page 20

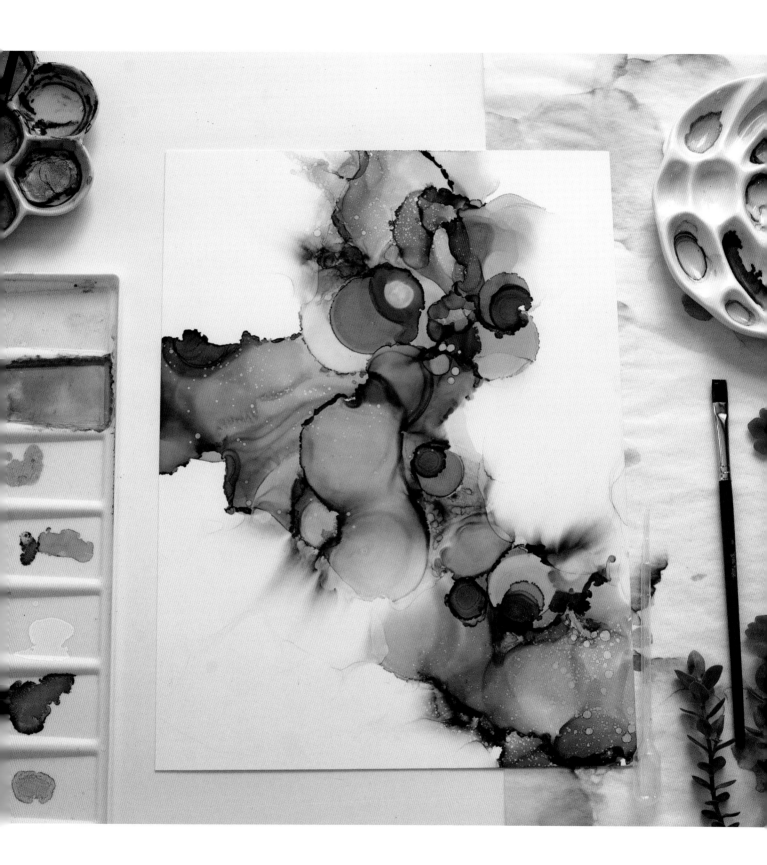

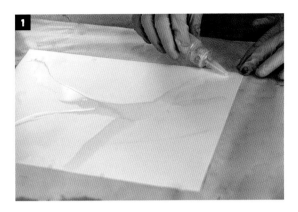

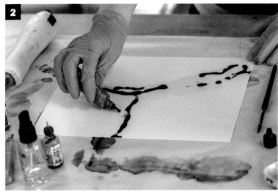

1 Place the Yupo paper on a protected worktable. Unless you have chosen to paint in a more intuitive manner, try placing the inspiration for this painting somewhere near you so you can reflect on it throughout the process. Select a color palette of three to five colors. Start by loosely mapping out your composition with isopropyl. This step doesn't set the composition in stone. It's just a foundation for where you want to apply the ink.

2 To create an alcohol ink wash, drop a couple of alcohol ink colors onto the isopropyl that you laid out in step 1. I used a light bluish green and dark blue for my base layer.

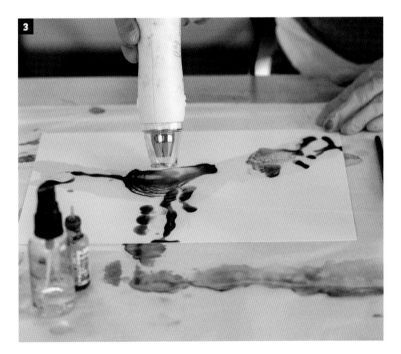

3 Using a heat tool or an air supply, push the alcohol ink across the paper following the composition you mapped out with isopropyl. Keep in mind that you are working with a fluid medium, so your composition won't always be exactly what you planned. Learning to let go and let the medium lead you opens your composition up to new and exciting discoveries that you can replicate in future paintings once you've learned how alcohol ink moves and reacts.

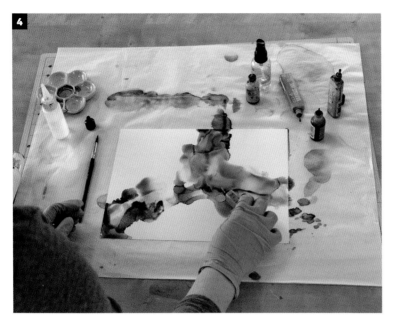

4 Continue to apply the heat tool or air supply and drop more alcohol ink onto the surface. Notice the foundation of your composition start to emerge as exciting textures and shapes form.

5 Squeeze a nickel-size drop of isopropyl on one of the edges of the alcohol ink painting and use your breath or an air tool to push the isopropyl up into the alcohol ink, creating a lovely blended arc to your ink wash.

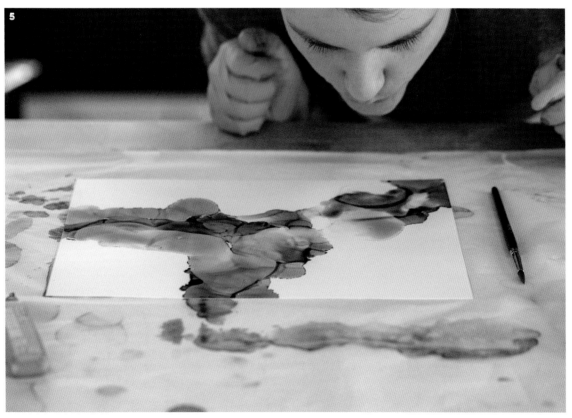

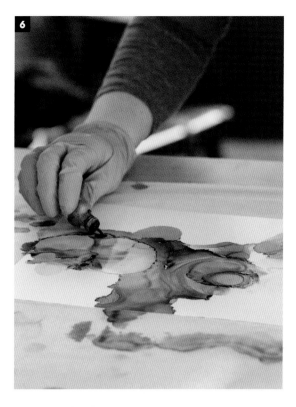

6 Round out the painting and add interest by selecting areas where you want to apply more alcohol ink colors. I dropped in a little yellow and pink to fill gaps, which will help unite the composition.

7 Creating a subtle fade along a dry alcohol ink edge is a great way to soften a painting. Select a dry (or almost dry) alcohol ink edge and run the tip of the isopropyl bottle along the edge, squeezing out just a little as you go. The isopropyl will push the alcohol ink back into itself as it reactivates the ink. Quickly take a heat tool and direct the air to push the reactivated alcohol ink out toward the edge of the paper. Experiment with this technique by adding a mix of alcohol ink and isopropyl to an edge and spreading the mixture in the same manner. Keep playing with the ratio of alcohol ink and isopropyl to find the sweet spot for your painting.

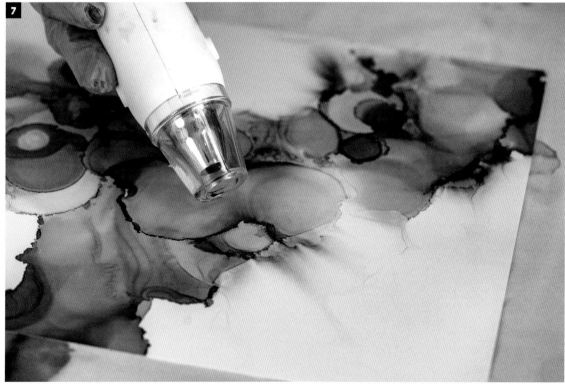

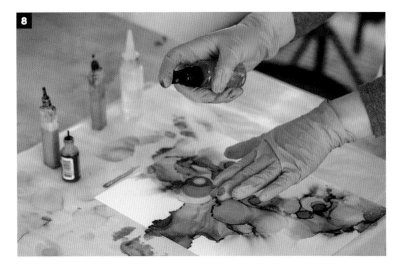

8 Spray a light mist of straight iso-propyl onto an area that you want to enhance with a bit of texture. This is also a great technique when you want to mask an area that you aren't completely happy with, as an isopropyl mist does a lovely job of hiding mistakes.

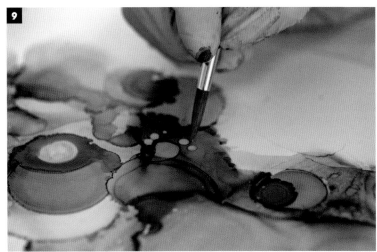

9 When the composition is in a place that you're happy with, take this time to see whether you want to add any more details or textures. If you feel it's finished, stop and seal the painting. To further enhance the painting with texture, stipple in a few blooms of straight isopropyl with a round brush. You can follow a natural line that appeared in the ink wash or randomly apply where you think it makes sense. Seal your painting using the process on page 64.

Porcelain Picture Frame

For this project, we will paint a white porcelain frame. Because art speaks to everyone differently, gifting fine art paintings can be a challenge, but this frame is a lovely alternative yet still an original and unique gift. Blank white porcelain frames can be purchased online with a simple Google search or at craft or discount home stores.

What makes working on porcelain so much fun is how the alcohol ink and isopropyl resist the surface. This pairing makes pretty textures and compositions that would take a little more work to create when painting on other surfaces.

WHAT YOU'LL NEED

Porcelain picture frame

91% isopropyl or blending solution in a craft bottle

Paper towels

Nitrile gloves

Alcohol inks in 3 to 5 colors

Heat tool/air supply

White glazed ceramic tiles (optional)

Gold mixative (optional)

Paintbrush (optional)

Spray bottle

Safety supplies from page 20

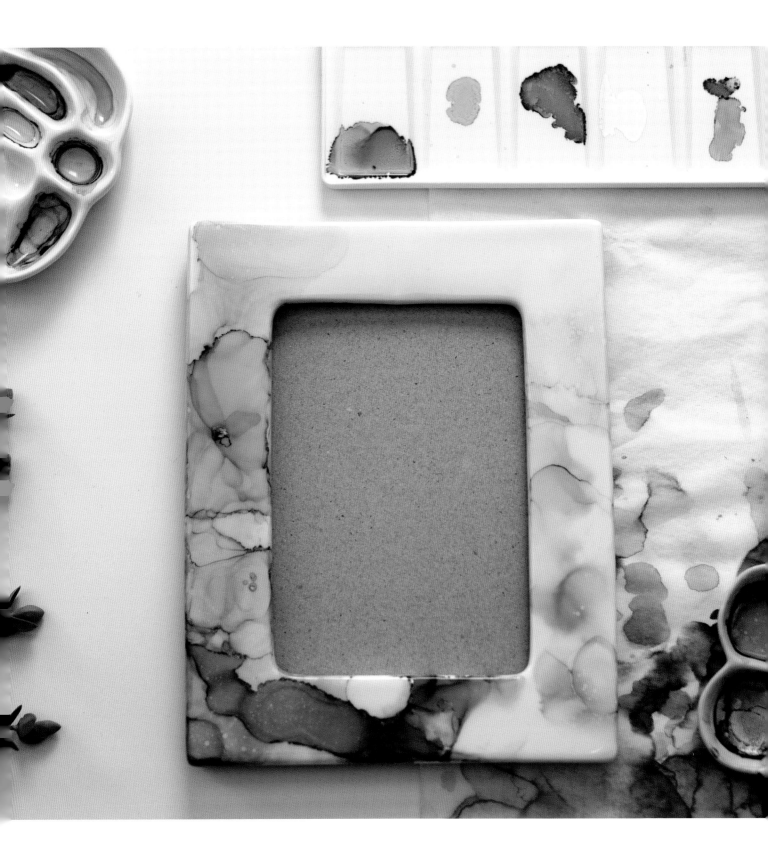

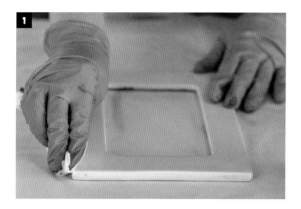

1 Place the frame on a protected worktable and remove the glass and any backing that it came with; set aside. Pour a little isopropyl onto a paper towel and wipe the frame clean of any fingerprints, dust, or dirt. It's a good idea to wear nitrile gloves so you don't transfer new fingerprints to the frame.

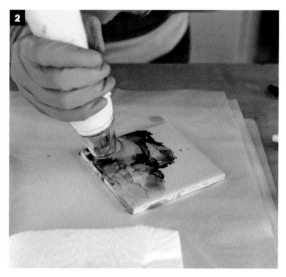

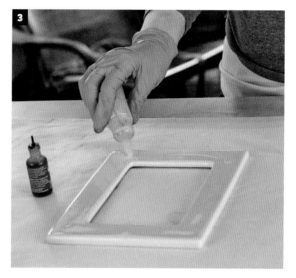

2 Choose three to five alcohol ink colors for your palette. You can completely remove alcohol ink that has been applied to porcelain with a paper towel and straight isopropyl, so exercise your creativity and don't worry about getting it right the first time! If you want to experiment with color palettes before working on the frame, purchase a few white glazed ceramic tiles from your local home improvement store. I used these alcohol inks for this project: Sardonyx (Copic), Ice Ocean (Copic), Denim (Tim Holtz), Rich Gold (Piñata).

3 It's time to determine how you want the ink to flow on the frame. Do you want to have negative space, or the surface entirely covered with ink? How textured do you want your piece to be? For this frame, I created a darker palette at the bottom and lightened my palette as I worked up to the top until it faded out to white. It's perfectly fine if at any point in the process you pivot from the original plan; sometimes you're forced to redirect due to the fluid nature of alcohol ink, and other times you see the medium taking you in another direction that looks more exciting. Loosely apply isopropyl to the frame based on the composition you've chosen.

4 Start by applying the alcohol ink wherever makes sense with the composition you decided on. I started at the bottom of the frame with a dark blue.

5 As you drop the ink onto the frame, work quickly between applying alcohol ink, isopropyl, and a heat tool or an air source to push the ink where you want it to flow. Notice when painting on porcelain the isopropyl rapidly pushes the alcohol ink on its own, creating fascinating little compositions.

6 Keep building up the colors and adding isopropyl where you want to lighten and blend the ink. Remember that ink beads up on a porcelain surface and needs to be moved with some sort of air source or your breath to encourage the flow.

7 When you are happy with the composition, try some of the techniques from earlier chapters. I added in a few bits of gold with my brush and applied a light mist of isopropyl for a little extra texture. When you are happy with your design and the ink is completely dry, seal the frame by following the instructions on page 66 for sealing porcelain.

Tree Silhouette & Night Sky Painting

The key to creating this dramatic sky is texture contrasted with a dynamic color palette. In this project, you will paint a simple yet stunning night sky complete with a sweet little silhouette tree line. You will use the ink wash and spray techniques that you learned in earlier chapters.

See the sidebar on page 97 for a quick tutorial on how to paint a tree silhouette.

WHAT YOU'LL NEED

Yupo paper

Nitrile gloves

91% isopropyl or blending solution in a craft bottle

Alcohol Inks in dark blue, teal, and dark pink

Heat tool/air supply

Small and medium round paintbrushes

Spray bottle/mister

Black acrylic paint

Palette

Safety supplies from page 20

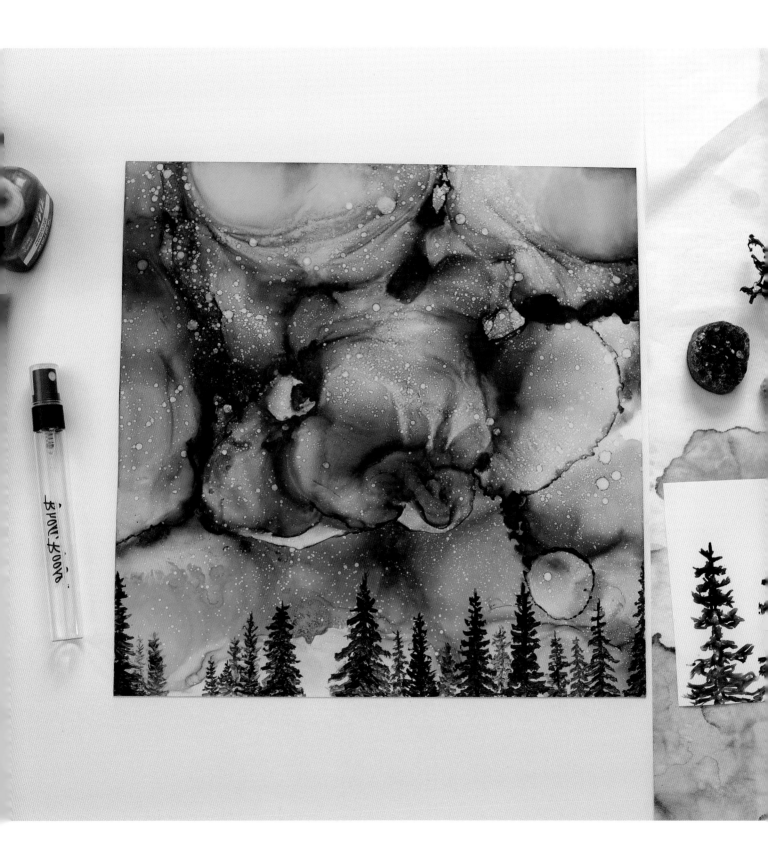

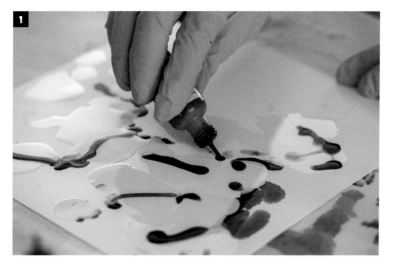

1 This project works best on Yupo paper because of the way the spray technique reacts with the ink. I used a 6" × 10" (15.5 × 25.5 cm) piece of Yupo. In this step, we will create an alcohol ink wash that covers the entire piece of paper. Place the paper on a protected worktable. Wearing gloves, lay down a good amount of isopropyl and then the dark blue and teal alcohol inks.

2 Tilt the paper back and forth, covering it with the alcohol ink and isopropyl mix.

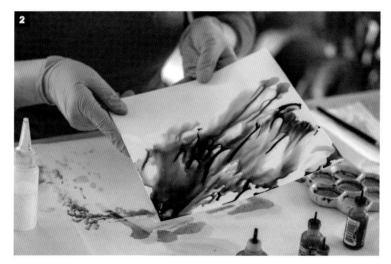

3 Start drying the alcohol ink mixture by using a heat tool or your breath. Notice how the shapes and textures form as you apply air.

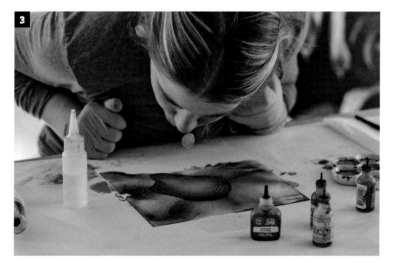

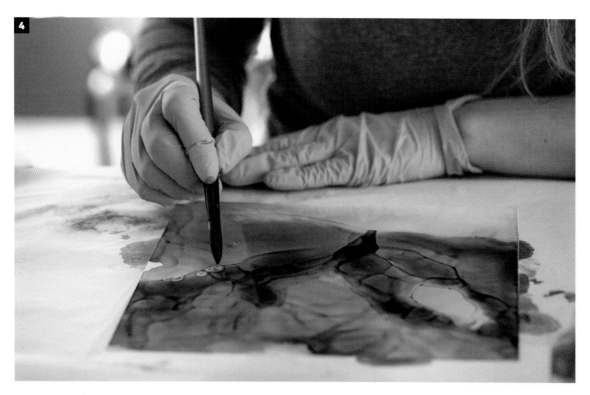

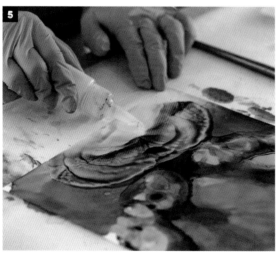

4 Add drama and texture to the sky by painting cloud-like textures with a paintbrush. Select an area where you want to use this technique, fill a medium round brush with straight isopropyl, and dab directly on top of the alcohol ink wash. Apply air immediately after application and watch cloud-like shapes appear as it dries. I like to have more control of the air supply, so I use my breath to dry the isopropyl when employing this technique.

5 I prefer to keep the bottom portion lighter so the dark trees stand out against the background. Apply dark pink ink to the bottom of the paper, quickly drop isopropyl in the center of the ink, and use your breath or an air supply to forcefully push the dark pink up into the blue sky.

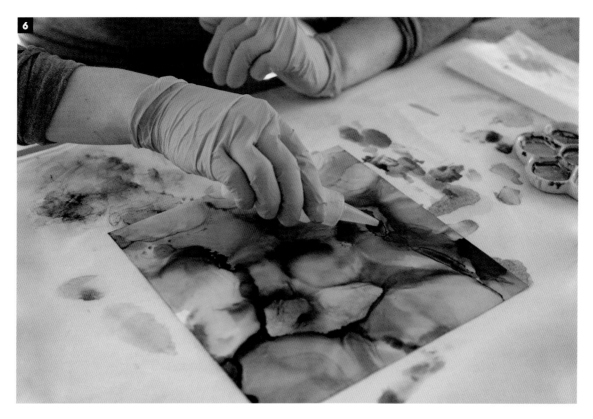

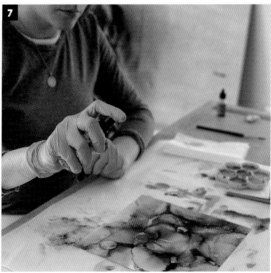

6 Your piece won't look exactly like mine, so you have to decide whether you like it as is or want to add more alcohol ink and/or techniques to it. I wanted to bring a little bit of the pink higher into the sky, so I found a natural line in the ink wash and ran the ink bottle along the edge, followed by isopropyl on top to blend.

7 Creating the stars is the most fun and the easiest part of this process! Take a mister filled with straight isopropyl, hold your hand about 12" (30.5 cm) above the paper, and press a half pump. Notice pretty little star-like dots start to appear in the sky. Keep slowly misting isopropyl onto the sky until you are happy with it. The closer you spray the mister to your paper, the more concentrated the dots will appear in one place. To stop the dots from blooming, use your breath or a heat tool to quickly evaporate the isopropyl.

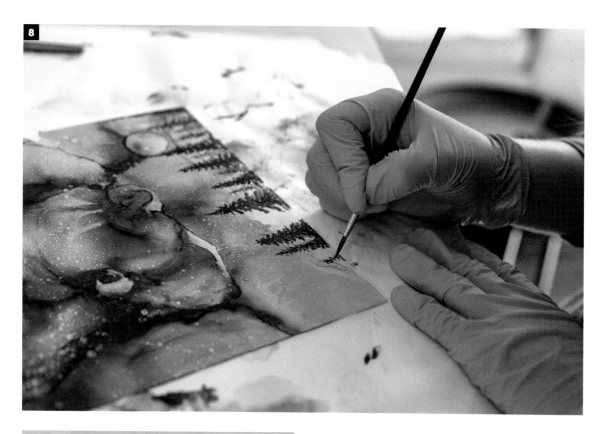

PAINTING TREES

For reference, find a few trees online and keep them in view while you're painting. Practice painting trees on a separate piece of paper before working on your original painting. Try to keep your brushstrokes loose so the trees look natural against the abstract sky you painted.

8 Now it's time to paint a little silhouette tree line. Fill a small round pointed brush with black acrylic paint and offload the excess by scraping the brush along the edge of the palette. I like to start with painting one medium-height tree in the middle of the paper; this creates a starting point that I will vary the tree heights around. The tree line doesn't have to extend the length of the paper. If you want to paint a cluster of trees and then leave a little clearing, that is perfectly fine! After your painting has fully dried, seal it using the directions on page 64.

Modern Ornament

One of my all-time favorite projects is painting abstract Christmas ornaments. This project really allows you to let go—the more texture and varied color palettes you use, the more these guys stand out! They also make for a unique gift. Porcelain ornaments can be purchased at craft stores or found in the blanks section of a sublimation company.

WHAT YOU'LL NEED

Porcelain ornament

Ornament holder

Nitrile gloves

Alcohol ink

91% isopropyl or blending solution in a craft bottle

Embossing heat tool or hair dryer

Metallic mixative

Safety supplies from page 20

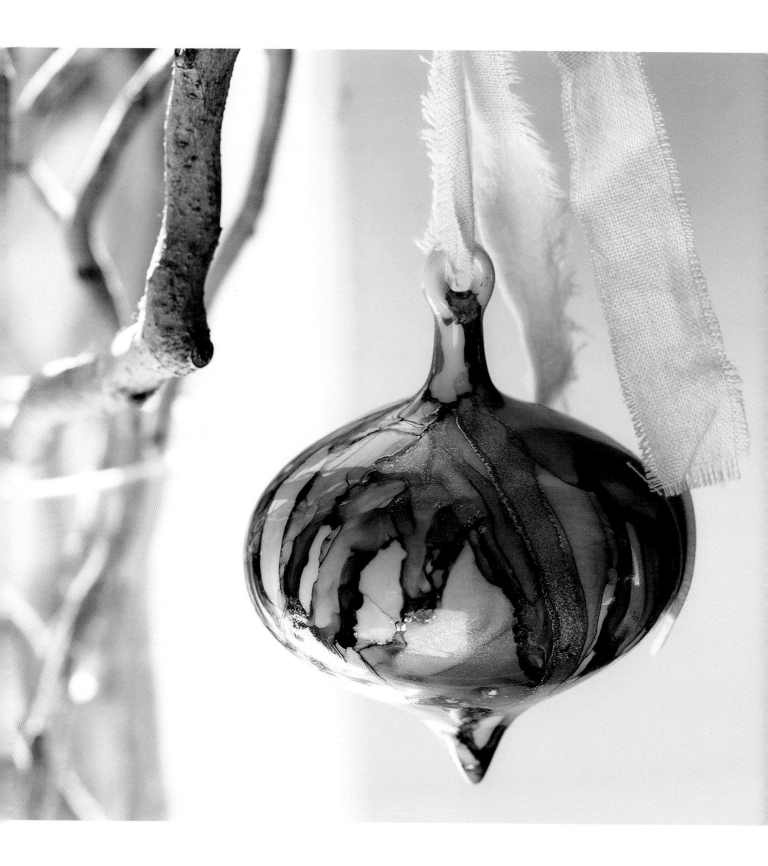

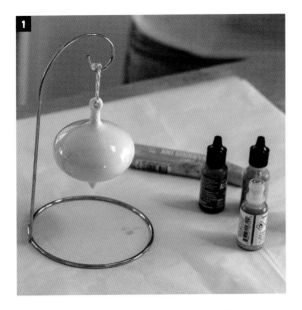

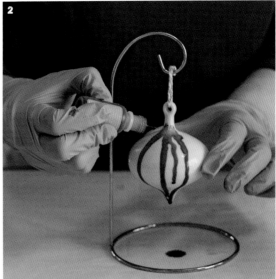

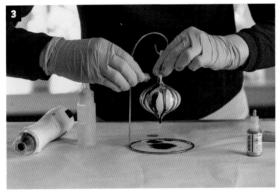

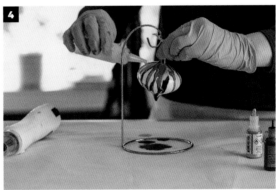

1 Make sure your worktable is protected, as there will be a lot of ink drips involved with this project! Hang your ornament by a string or hook on an ornament holder (or something that will do the same job).

2 Choosing a color palette that strays from the typical holiday scheme is a fun way to make your ornaments stand out against the sea of red and green. For this demonstration, I used a nontraditional palette of teal, navy, light pink, and gold mixative. Wearing gloves, and starting at the top of the ornament, squeeze a few drops of teal and let them drip down the ornament.

3 Apply the rest of the colors using the same method, leaving the rich gold mixative for later.

4 Start dropping on a little isopropyl and use the heat tool to push it around the surface.

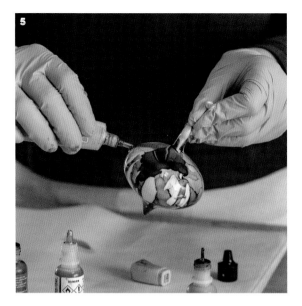

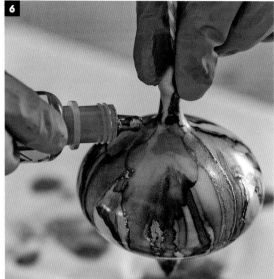

5 At this point, you need to move the ornament freely as the isopropyl reactivates the ink and the heat tool pushes it around, so it's often easier to remove the ornament from the holder and carefully grip the top of it so you can quickly work on all sides.

6 Thoroughly shake the metallic mixative and, from the top of the ornament, squeeze a few drops and then add a little isopropyl on top of the mixative, letting it run down.

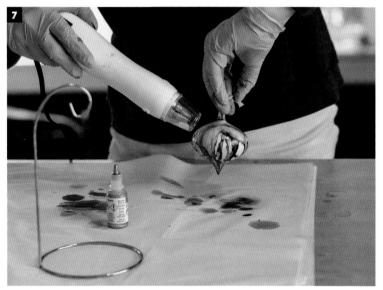

7 If desired, use an air tool to move the mixture around. Because we're working with a fluid medium, every ornament you create will differ from the next, and yours will differ from mine, so you'll need to decide when your ornament is finished or whether you want to add more alcohol ink, isopropyl, or mixative. I'll often repeat steps 2 through 6 until I'm happy with the texture and color palette of my ornament. After the ornament is fully dry, seal it using the instructions on page 66.

Ocean-Inspired Textured Painting

I love adding something unexpected to my alcohol ink paintings, and texture paste achieves this by creating an interesting three-dimensional texture that you typically don't associate with alcohol ink. In this project, we'll apply one layer of texture paste to our surface, then paint on top of it with alcohol ink.

Texture paste can be purchased at any art or craft store.

WHAT YOU'LL NEED

Painter's tape

Nitrile gloves

Gessobord or Claybord surface

Paste applicator such as a craft stick

Texture paste

91% isopropyl or blending solution in a craft bottle

Alcohol ink

Heat tool/air supply

Metallic mixative (optional)

Safety supplies from page 20

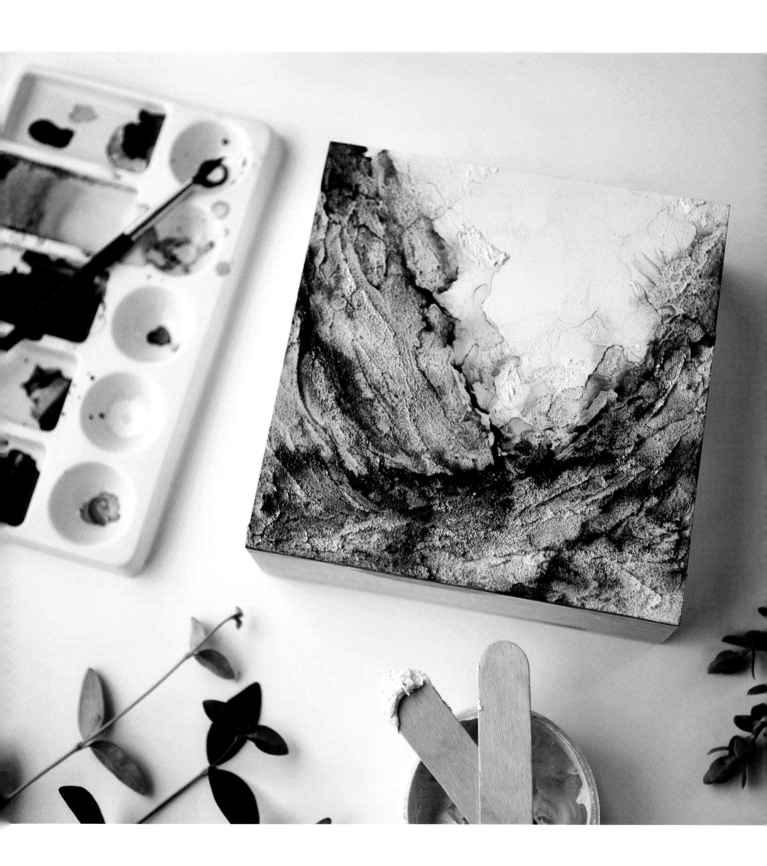

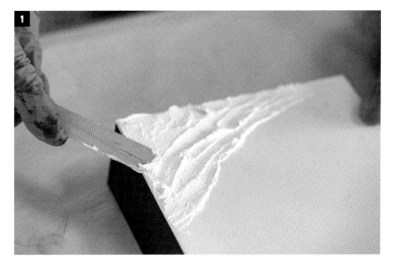

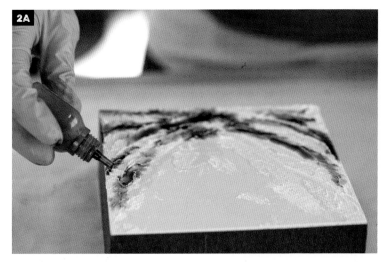

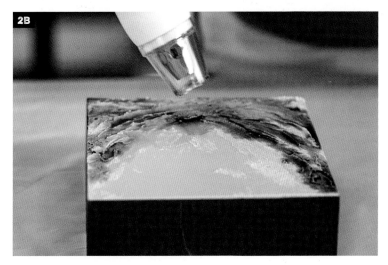

1 Working on a solid base such as Gessobord or Claybord is essential for this project. If the texture paste is applied to paper, it can crack and crumble off as the paper bends. For this project I used a 6" × 6" (15 × 15 cm) smooth Gessobord. Apply painter's tape to all sides of the cradled board to help keep ink off the edges. Put on gloves and place the Gessobord on a protected worktable. Using a craft stick or a similar tool, scoop out a bit of the texture paste and apply it to the Gessobord. Create depth and dimension by varying the height at which you apply the paste. Here I'm applying texture paste to the bottom of my surface, gradually using less until it fades out at the top, leaving some negative space. Once you are happy with the texture, let it dry for about 24 hours or until it's dry to the touch. Depending on how thick you applied the layer, it may take more or less time to dry.

2 Once fully dry, apply alcohol ink directly on top of the paste. Decide on a color palette and drop isopropyl and alcohol ink on top of the texture **(A)**, moving the mixture around the surface with a heat tool **(B)**. Notice how the ink nestles into the crevices of the texture paste, creating darker areas. Simply add isopropyl over any areas you want to lighten. Repeat this step until you're happy with the results.

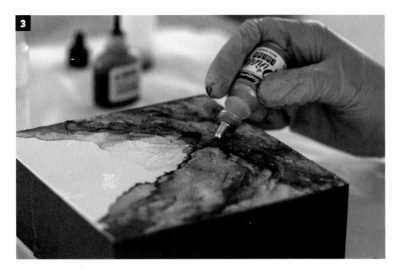

3 If you choose to add metallic mixative to your painting, apply it while the alcohol ink mixture is still wet. If the ink mix is too dry, just add more isopropyl and alcohol ink and drop the metallic mixative on top, then push the mixative around with your heat or air tool. Mixatives can really enhance a piece, giving it an all-around richness.

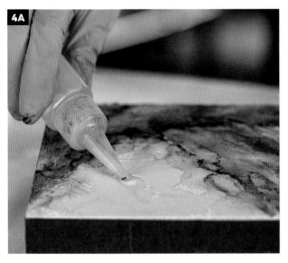

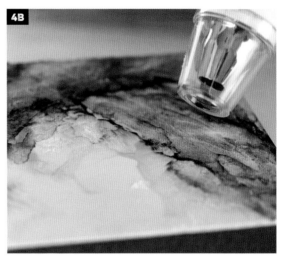

4 Apply a bit of isopropyl to the top edge of the alcohol ink application **(A)** and use your heat tool or air supply to fade out the alcohol ink into the white space by pushing the isopropyl and alcohol ink upward **(B)**. When the painting is fully dry, follow the sealing directions on page 64. This style looks great with a coat of resin, which adds protection against dust settling into the crevices. See instructions on page 70.

Abstract Coasters

Coasters are a lovely way to display functional art in your home. They also make great gifts. These coasters are finished with a glossy coat of resin, which gives them an extra pop of richness and depth.

WHAT YOU'LL NEED

Four white glazed ceramic tiles *(I used hexagons, but any shape will work; circles and squares are also popular.)*

Nitrile gloves

Paper towels

91% isopropyl or blending solution in a craft bottle with a pointed tip

Painter's tape

Alcohol inks in 2 or 3 colors

Embossing heat tool, hair dryer, *or* other air tool

Round paintbrush

Metallic mixative

Gold paint pen *(optional, for finishing the sides of the tiles)*

Adhesive cork circles

Resin and related supplies for sealing

Safety supplies from page 20

PREP FOR THE MESS

If you're reluctant to wear gloves, you'll definitely want to wear them for this project! Although it's on the messier side, I think it's one of the most rewarding.

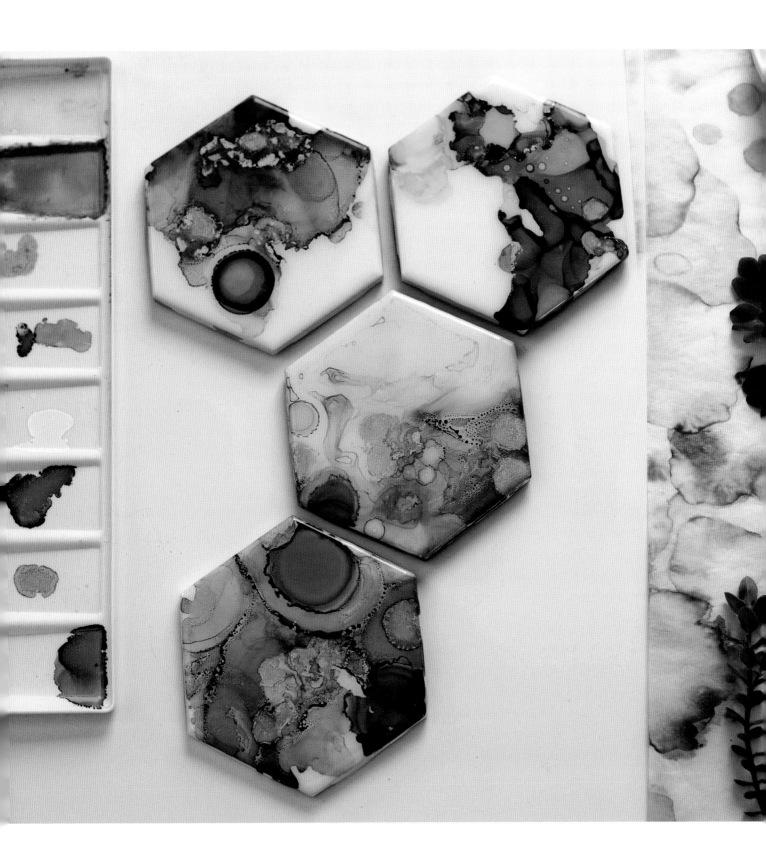

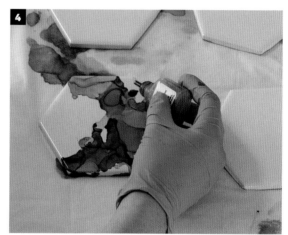

1 Place four tiles on a protected worktable. Use a paper towel moistened with a little isopropyl alcohol to clean the surface of the tiles, removing fingerprints and dirt. Tape the bottom of the tiles with painter's tape to keep resin drips from hardening there. Cut any tape that overhangs from the coaster's edge.

2 Choose a palette. Two or three colors are usually a good number to start with. If you use too many, your palette can start to look muddy. For this project, I used rose and turquoise from Brea Reese, but you can use any colors you like, or find similar colors from another brand. Wet one of the tiles with isopropyl alcohol and then apply one color of alcohol ink directly into it. (I started with turquoise.)

3 Use an air tool or your breath to spread the mixture across the tile.

4 While the alcohol ink and isopropyl are still wet, drop the second color of alcohol ink on the tile. I nestled the rose in next to the turquoise. Add more isopropyl alcohol if needed to help keep the ink fluid.

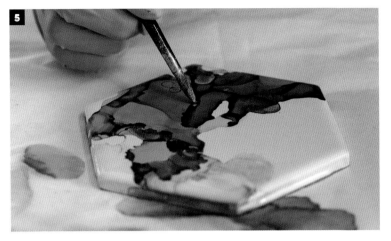

5 Use a round brush to drop metallic mixative onto wet areas of the painting. Watch how the mixative reacts with the alcohol ink and the isopropyl as it moves and fans out on its own. Keep applying alcohol ink, isopropyl, and mixative until you're happy with the composition. Let dry. If desired, finish the edges of each tile with a gold metallic pen.

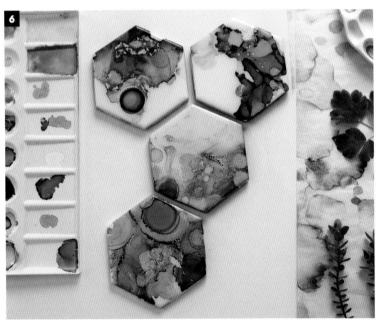

6 Repeat steps 1 through 5 to paint the other coasters in your set. Try to vary each coaster by using more of one or the other color on each. Experiment with the compositions on each tile to add some variety and balance. Create a good amount of negative space on one coaster and then fully cover the next with the alcohol ink mixture. The variations you get on each coaster are really what makes this project sing! Seal your coasters with resin (see page 70 for details).

DO-OVERS

If you're unhappy with the way a tile has turned out, the good news is that all is not lost! Simply wipe the tile clean with straight isopropyl alcohol and a paper towel and start again.

I sometimes find that it takes a couple of tries to create a piece I'm happy with, so don't feel as if you've failed if you decide you need a do-over.

Mini Abstract Landscape

In this project, we explore how to create a simple yet beautiful abstract landscape composition. The key here is to keep it simple and loose; really lean on your color palette and the composition to make this piece sing. I like to use quite a bit of negative space when painting abstract landscapes. The balance of the clean white space next to the exciting textures and color palette of the landscape contrast with each other nicely. I'll show how I create an abstract ocean and cliff landscape, complete with a dramatic sky.

WHAT YOU'LL NEED

Yupo paper or alcohol ink card stock

Nitrile gloves

Alcohol ink

91% isopropyl or blending solution in a craft bottle

Round paintbrush

Paper towels

Palette

Spray bottle (optional)

Paint pens (optional)

Safety supplies from page 20

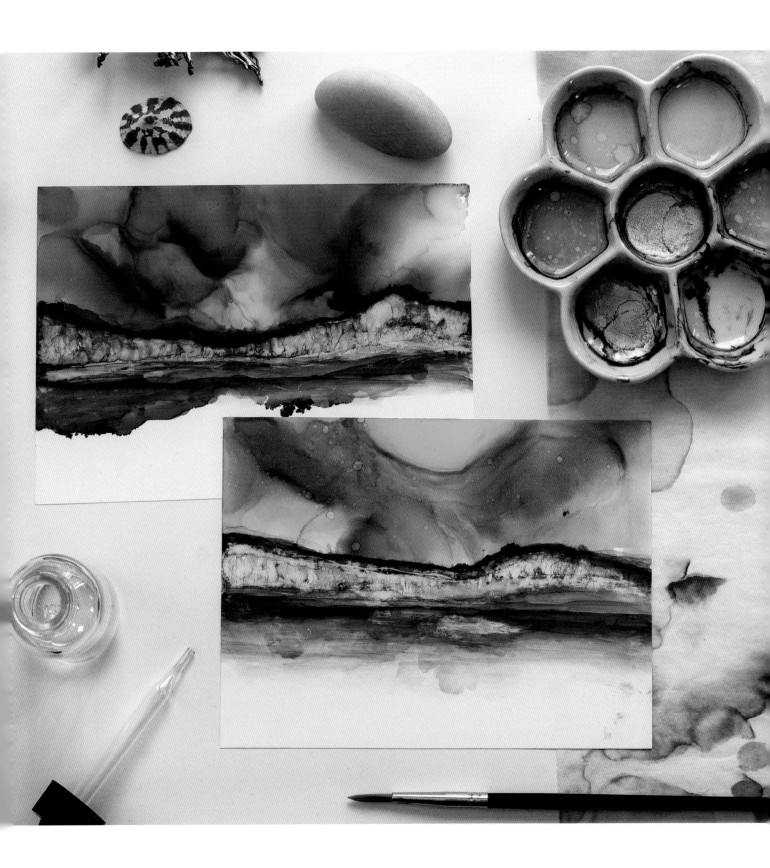

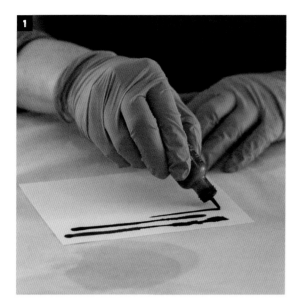

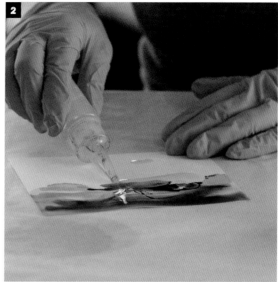

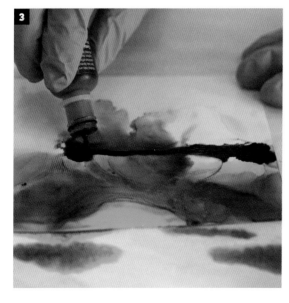

settled on a color palette, start by laying down alcohol ink for the sky. Start at the top and squeeze out the ink directly from the bottle, moving from left to right. Start with the darkest color and move down to the lightest until you hit the space you want to paint the cliffs. I started with teal and faded down to pink.

2 Apply isopropyl over the alcohol ink, tilt the paper back and forth, and watch the colors blend.

3 Take the alcohol ink you selected for the cliff (I used a purplish gray for the top and then a medium brown) and vary the height of the alcohol ink as you run it across the paper to mimic the highs and lows of a natural cliff line. As the alcohol ink hits the Yupo paper, it will start to move and bleed, giving it a fun, organic look. After you've applied the cliff color, loosely lay down the ocean color from left to right, using a round paintbrush to blend. Fade out the bottom part, leaving quite a bit of negative space. I mixed the teal from the sky and the purplish gray at the cliff top to create the color for the water.

1 Place a 4" × 6" (10 × 15 cm) piece of Yupo paper and a few 3" × 3" (7.5 × 7.5 cm) scraps of Yupo on a protected worktable. Put on your gloves. Before deciding on a color palette, practice different color mixtures on scrap Yupo paper. This experiment helps you understand how the colors look in relation to one another. Once you've

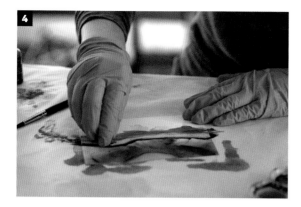

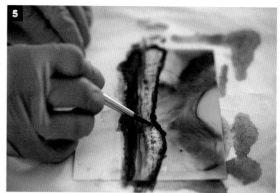

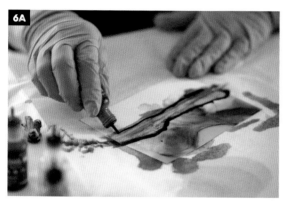

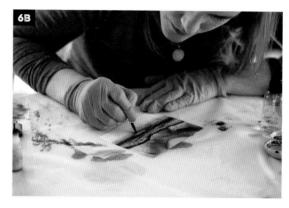

4 To lighten the cliff faces, take a small piece of paper towel dipped in isopropyl and start to lift the alcohol ink from the cliff face. Try not to disturb a small top portion of the cliff, which will act as the grass. Continue to lift until you are happy with it.

5 To give a rocky effect to the cliff face, dip a round paintbrush dipped in isopropyl and offload the excess so it isn't dripping off the brush. Alternately applying the brush on its side and on the tip, start to dab the brush and use your breath to quickly dry the isopropyl, leaving behind a craggy rock texture. Continue this down the length of the cliff and repeat until you are satisfied with the effect.

6 Blend down the water line a bit more in loose, quick motions **(A)**. You can also blend the water up onto the beach as well as add more alcohol ink to the water, using your paintbrush to blend and add movement **(B)**.

After you've applied all the alcohol ink layers, keep the piece as is or enhance the landscape by dropping in isopropyl or more alcohol ink for added texture. I prefer my landscapes to stay very loose—almost completely abstract with slight details. Using blocks of color and relying on the medium to create organic texture helps achieve this look. If you like a less abstract look, take this time to experiment with a few techniques: maybe add a mist of isopropyl to the sky or water mimicking the spray of the ocean or use paint pens to draw in details that would help further define the shapes. Seal the painting using the instructions on page 64.

Crescent Moon Painting

Moons, galaxies, and planets have always been popular subjects to paint, and the magical textures that alcohol ink can create makes it the perfect medium to paint these dreamlike worlds. In this project, we emboss a crescent moon over a starry night sky of an alcohol ink wash.

WHAT YOU'LL NEED

Yupo paper

Wood craft circle, 8" (20 cm)

Paintbrush to mount Yupo paper

Heavy matte gel medium

Cutting mat

Craft knife, such as X-Acto

Nitrile gloves

Alcohol ink

Heat tool/air supply

91% isopropyl in a small spray craft bottle

Kamar varnish spray

Circle template, 8" (20 cm)

Embossing pen

Embossing liquid

Gold embossing powder

Stiff paintbrush

Embossing heat tool

Adhesive plate hangers (optional)

Safety supplies from page 20

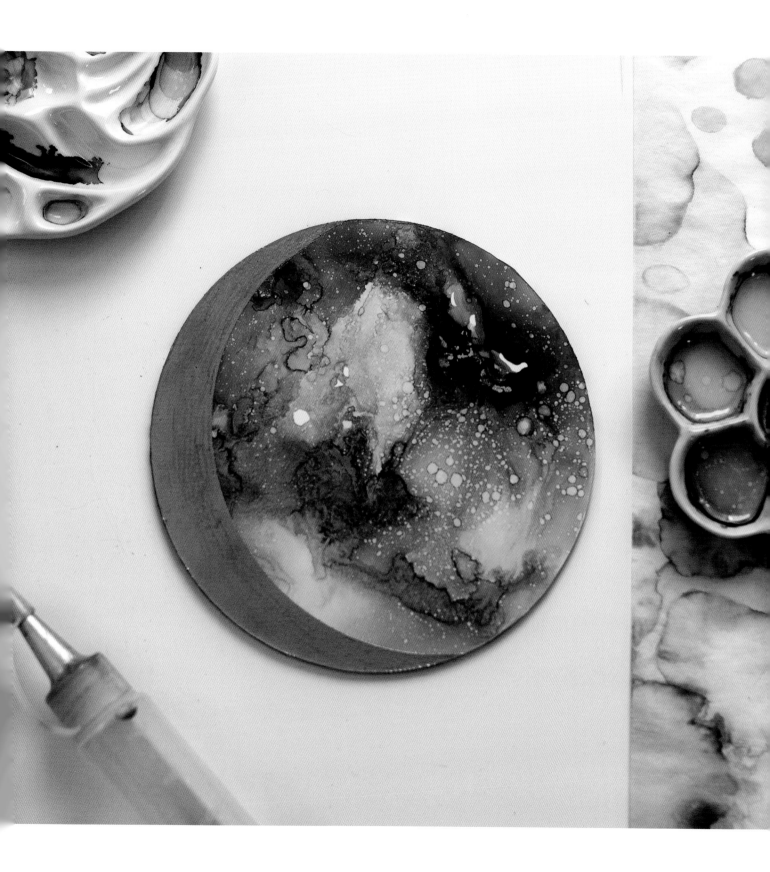

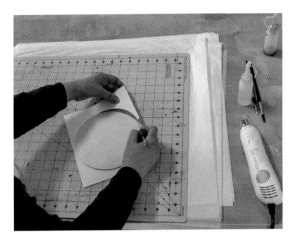

1 The first step is adhering the Yupo paper to the wood surface. Cut the paper about ½" (1.3 cm) larger than your board; it doesn't need to be a perfect circle because we will cut the overhang once the paper has fully dried to the board. Using a dedicated paintbrush for glue and the gel medium, follow the mounting instructions on page 67 and let it sit for about 24 hours or until dry. Flip over the Yupo paper so it is front side down and place it on a cutting mat. Cut around the edge of the Yupo paper with a craft knife, getting as close as you can to the edge without cutting the board.

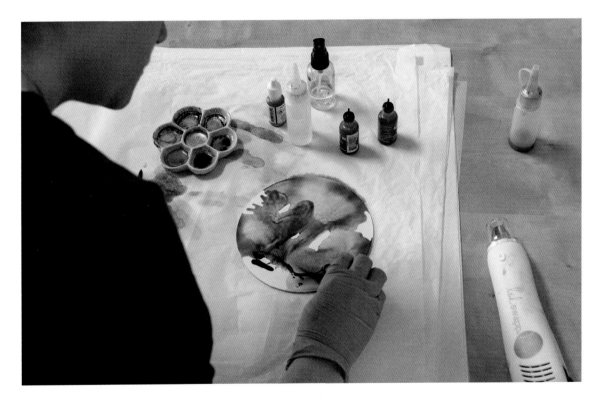

2 Put on the gloves and paint an alcohol ink wash to mimic a night sky. Here I've used navy, blue-green, gray, and dark pink. Use your breath or an air supply to push the ink around the surface.

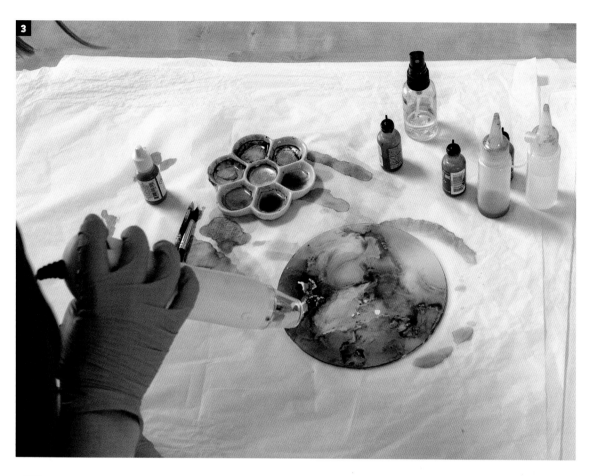

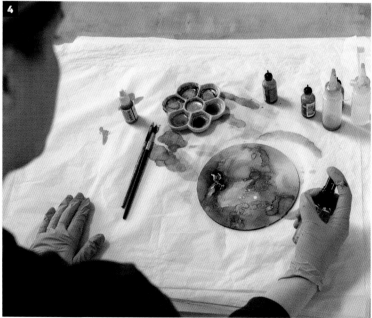

3 As the alcohol ink wash blends and dries, you will see pretty textures start to form, adding dimension to the sky.

4 Add a light spritz of straight isopropyl to the alcohol ink wash, creating a star-like texture in the sky. When you are happy with the ink wash and it's fully dry, seal it with one coat of varnish to keep the ink from activating in the next step. Use the sealing instructions found on page 64.

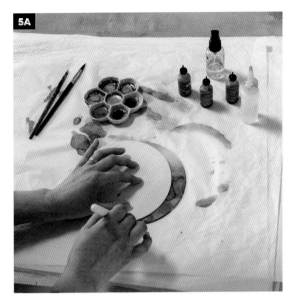

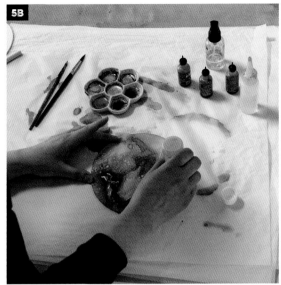

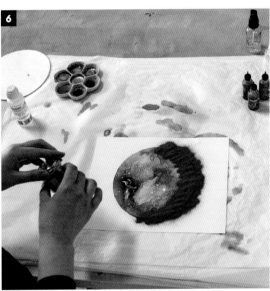

5 Once the varnish is dry, use a circle template about the same size as your circle to draw a crescent moon onto the ink wash with an embossing pen **(A)**. Apply the embossing liquid (you can use an embossing pen if you like) to the inside portion of the crescent moon **(B)**. Make sure you get complete coverage with the embossing liquid or the embossing powder won't stick and you may see small holes in the final product where the embossing powder wasn't applied.

6 Dump the embossing powder on top of the embossing liquid application, making sure to cover the moon entirely.

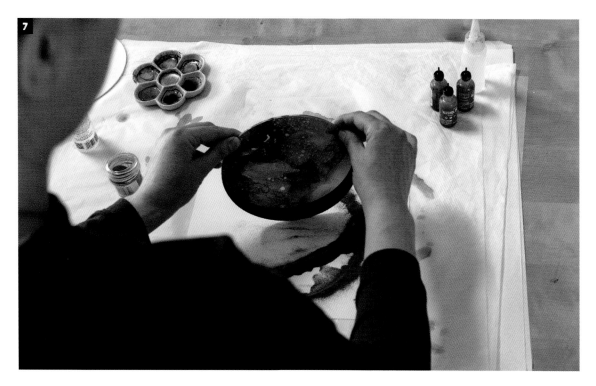

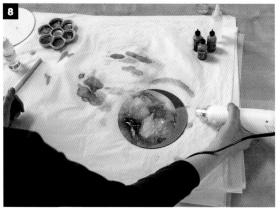

7 Tap the painting onto a clean sheet of copy paper to remove any excess embossing powder and transfer the excess powder back into the bottle. If you see areas that didn't hold the embossing powder, go back with the embossing liquid and carefully add more to the bare spots, pour more embossing powder on top, and tap off the excess once again. Using a stiff paintbrush, remove any embossing powder that stuck to other areas of the painting that you don't want embossed.

8 Wait about 15 minutes for the embossing liquid to dry, then use the embossing heat tool to apply heat to the embossing powder. As the embossing powder heats up, it will melt into a smooth plane of gold. If you didn't get a good application of gold, add another layer by repeating steps 5B through 8. Seal the painting following the instructions on page 64. To really make this project pop, try adding a coat of resin to the completed piece (see page 70). To display your piece on a wall, use adhesive plate hangers.

Circle Painting

You've learned by now that alcohol ink is an unpredictable medium, but there are ways we can try to control it to a point. Contact paper is a great tool to rein in alcohol ink. Cutting your own contact-paper stencils allows you to customize your designs and contain the ink with little to no bleeding under the stencil. In this project, we will cut a circle stencil that will stick to the surface during the painting process and then be removed to reveal a clean, crisp circle of contained alcohol ink.

WHAT YOU'LL NEED

Cutting mat

Scissors

Contact paper

Pen

Circle cutter (optional)

Transfer paper (optional)

Waterproof panel, medium weight Yupo paper, or Gessobord, 8" × 10" (20 × 25 cm)

Nitrile gloves

Alcohol ink

91% isopropyl or blending solution in a craft bottle

Heat tool/air supply

Spray bottle/mister

Medium round paintbrush

Metallic mixative

Safety supplies from page 20

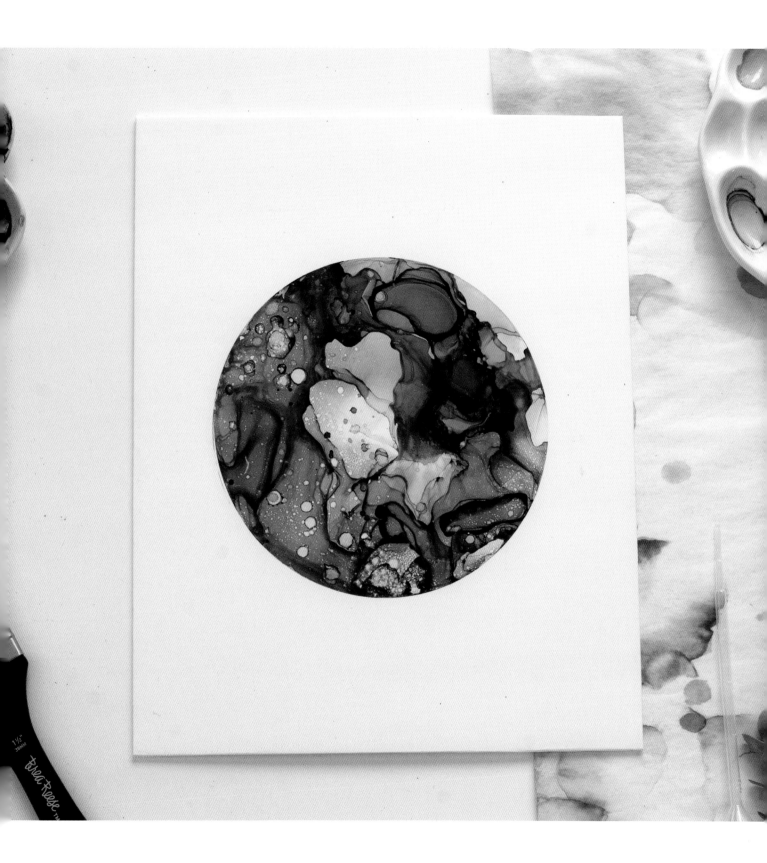

1 Start with a clean cutting mat on your protected worktable. Cut out an 8" × 10" (20 × 25 cm) piece of contact paper, remove its backing, and lay the sticky side down onto the cutting mat. Find the center point and mark with a pen. Place the circle cutter on the center mark, cut out the circle, and remove from the rest of the contact paper.

2 Cut the transfer paper just slightly larger than the 8" × 10" (20 × 25 cm) sheet of contact paper, carefully peel it from its backing, and place evenly on top of the contact paper, pressing down and smoothing over any bubbles. Start at one edge and slowly lay down the transfer paper, smoothing it out as you go.

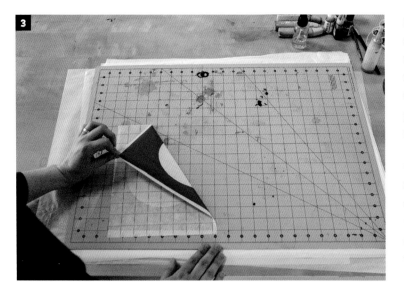

3 Once the transfer paper has been applied, pull up one edge. Notice that the contact paper is stuck to the underside; carefully keep pulling the transfer paper and contact paper off the cutting mat until they're completely removed.

4 Place an 8" × 10" (20 × 25 cm) substrate onto your table. I used a pre-cut 8" × 10" (20 × 25 cm) waterproof panel from Brea Reese, but any substrate that takes alcohol ink will work. To transfer the contact paper stencil centered onto the surface, match the top edge and corners of the contact paper to the surface and slowly lay down the stencil from top to bottom, smoothing out any bubbles or wrinkles as you adhere it to the panel. Continue to smooth it over with your hands, concentrating on the edge of the circle to make sure it has a tight bond so ink doesn't leak under. You can now remove the transfer paper to reveal the circle you will be painting in.

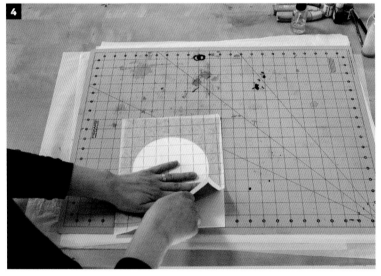

TROUBLESHOOTING

Sometimes the transfer paper initially has a hard time picking up the contact paper. You can help it along by pulling up the contact paper corner and manually sticking it to the transfer paper; once you get one edge applied to the transfer paper, the rest will easily pull up.

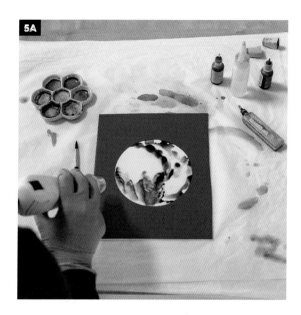

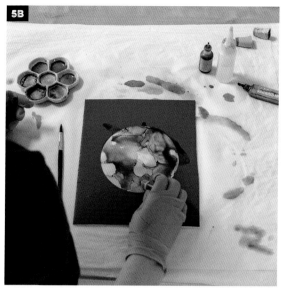

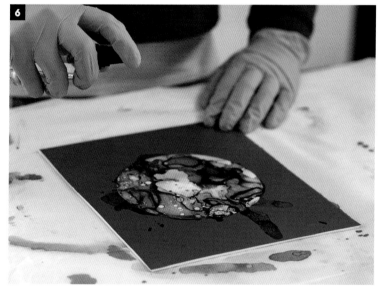

5 Now for the fun part! Put on your gloves and create an alcohol ink wash with alcohol ink and isopropyl in the center of the circle. Use a heat tool to spread the alcohol ink around the circle **(A)**. Add more ink if desired **(B)**.

6 Spritz straight isopropyl onto a section of the painting. Use your hand or a piece of paper to cover areas of the painting that you don't want sprayed.

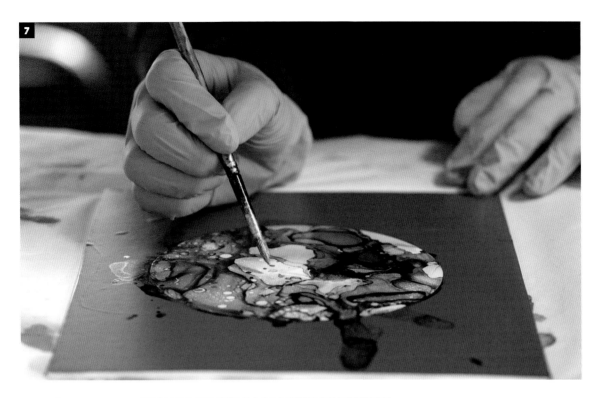

7 Use a medium round paintbrush to stipple in a metallic mixative or use straight alcohol ink to stipple in color.

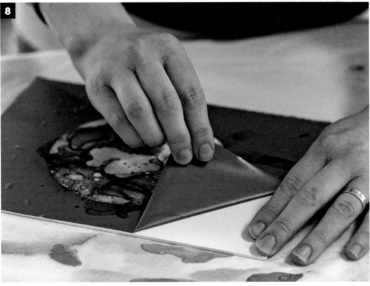

8 After the ink has fully dried, slowly peel up the contact paper to reveal the crisp circle painting. To finish, seal the painting using the instructions from page 64 and frame for added protection.

Geometric Painting

This project is an exciting way to incorporate a lot of the techniques in Chapter 2. The finished piece can be quite versatile; it can be used for many applications and on many different surfaces. Create decorative paper for scrapbooking or a fine art painting, or practice drawing designs with paint pens.

WHAT YOU'LL NEED

Cutting mat

Scissors

Contact paper

Painter's tape (optional)

Thin nib permanent marker, such as Sharpie, or pen

Metal-edged ruler

Craft knife, such as X-Acto

Transfer paper

Yupo paper (medium weight)

Nitrile gloves

Alcohol ink

91% isopropyl or blending solution in a craft bottle

Heat tool

Round paintbrush (optional)

Store-bought adhesive stencil

Paper towels

Paint pens, white and black

Spray bottle (optional)

Embossing tools (optional)

Metallic markers (optional)

Safety supplies from page 20

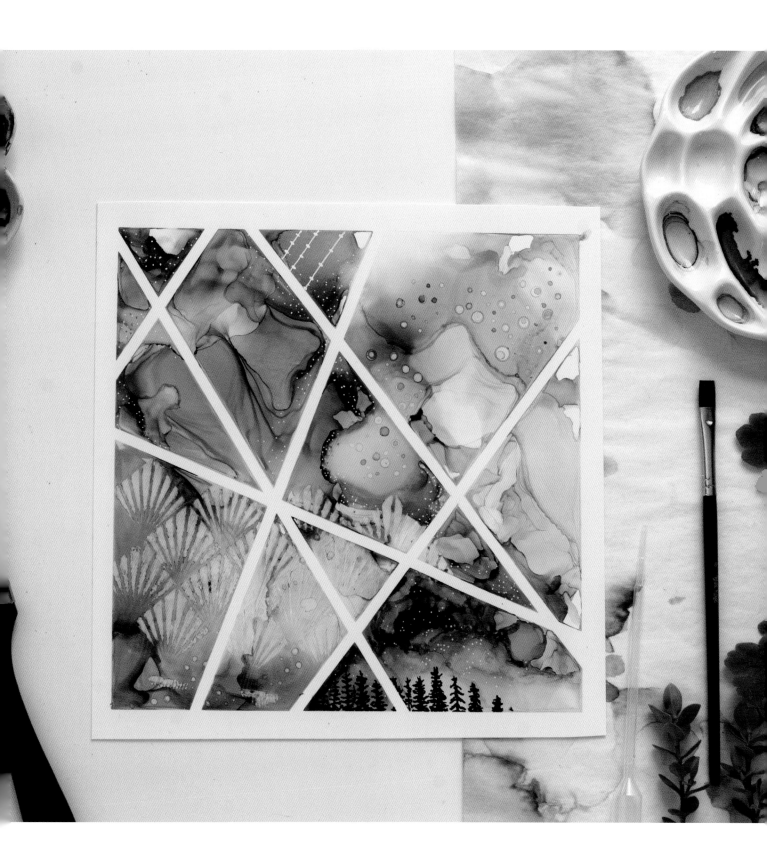

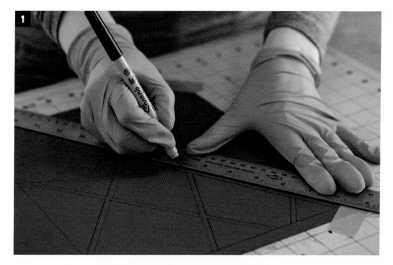

1 Start with a clean cutting mat on your protected worktable. With scissors, cut out a 9½" × 9½" (24 × 24 cm) piece of contact paper, and tape down the corners onto the cutting mat. Sketch out a few different compositions before drawing on the contact paper. Once you've decided on a composition, use a thin nib permanent marker or pen and the ruler to draw your composition.

2 Cut the shapes out with a metal-edged ruler and a sharp craft knife **(A)**. Don't worry if you accidentally cut too deep and remove some of the contact paper's backing— you only need the contact paper for this project. Once you have finished cutting the shapes, remove them from the contact paper, leaving behind a stencil created from the lines you drew **(B)**.

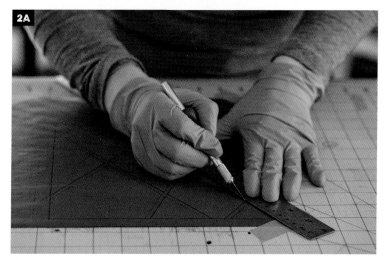

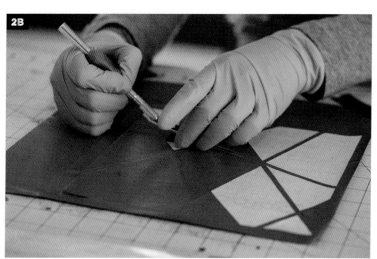

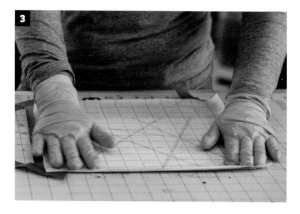

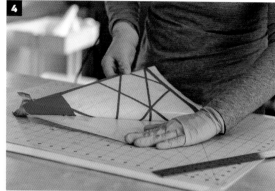

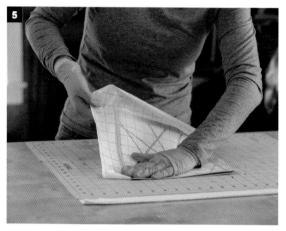

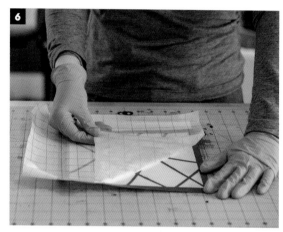

3 To remove the contact paper stencil and apply it to the Yupo paper, cut a 10" × 10" (25 × 25 cm) piece of transfer paper and place it over the contact paper, sticky side down, leaving a little overhang around the contact paper. Smooth it down to release bubbles as you are placing the transfer paper.

4 Pull up a corner of the transfer paper to make sure the contact paper has adhered to the back, and then carefully pull up the transfer paper with the contact paper.

5 Now it's time to transfer the contact paper stencil to your surface. Place a 9" × 9" (23 × 23 cm) piece of Yupo paper on the worktable and evenly lay down the stencil that is still adhered to the transfer paper, smoothing out any bubbles as you go. Sometimes the transfer can go awry, so go slowly and carefully realign the stencil as needed, because once the stencil is completely down, it is hard to readjust.

6 Remove the transfer paper, leaving behind the contact-paper stencil. Make sure the stencil has a tight bond to the surface by smoothing it over with your hands.

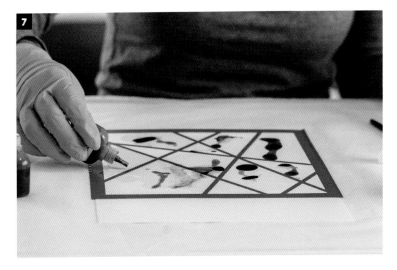

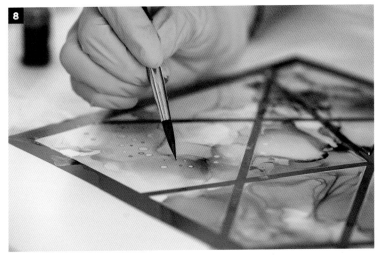

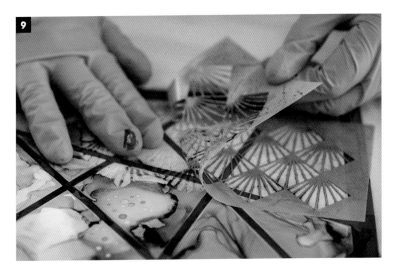

7 Select your color palette. I used dark blue and orange. Wearing gloves, paint an ink wash by randomly dropping isopropyl and alcohol ink onto the surface and using a heat tool to move the ink mixture over the paper. Apply more alcohol ink and isopropyl until you are happy with the composition. If you are working with complementary colors like I did, be careful to not let them mix too much or your palette will become muddy (unless a neutral palette is what you're going for, then mix as much as you want!). I let the blue and orange mix just a bit in selected areas where I wanted it a little more neutral. Let dry.

8 It's time to embellish your shapes! Try using techniques you learned in the beginning chapters. I chose to first stipple in little blooms with a round paintbrush in the upper right corner using straight isopropyl. I also stippled little blooms of straight alcohol ink onto the ink wash. I trailed the blooms down into an adjacent shape to add some unity to the painting.

9 Press the store-bought adhesive stencil onto the surface, laying it across a few shapes. Take a paper towel dipped in isopropyl and start lifting the alcohol ink by dabbing it on the stencil. After the isopropyl is fully dry, remove the store-bought stencil, revealing the design.

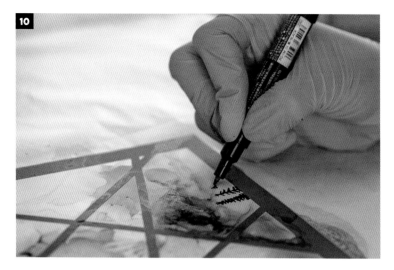

10 The bottom section is a fun place to add a silhouette tree line. Take a black paint pen and loosely draw in little trees. I chose to expand the tree line to an adjacent shape for unity and flow. Add little white dots to the sky just above the trees.

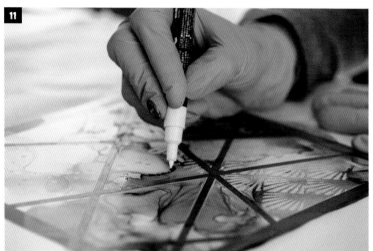

11 Continue to stipple in little white dots throughout the painting. To further enhance the project, draw more designs inside the shapes with paint pens or emboss a few of the shapes. You can also spritz with isopropyl or outline the shapes with a metallic marker. The options are endless!

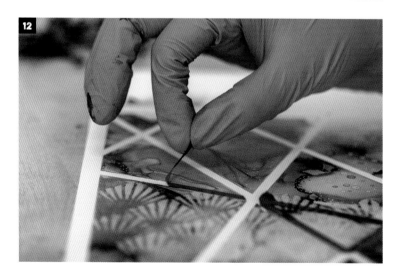

12 Once you are happy with the painting and it is fully dry, carefully peel off the contact-paper stencil, revealing the white of the paper and your geometric design. Seal your painting using the instructions on page 64.

Custom Greeting Cards

In a digital world, there's something really special about receiving a greeting card and even more so when someone took the time to make it. In this project, I show you how to create customized greeting cards using an adhesive stencil along with a couple of other ideas to create unique cards. You can also make reproductions of your cards by scanning and printing them at your local copy center (see page 78).

WHAT YOU'LL NEED

Yupo paper, cut to 4" × 6" (10 × 15 cm) (or whichever size you prefer)

Store-bought adhesive stencil

Alcohol ink

91% isopropyl or blending solution in a craft bottle

Heat tool/air supply

Vellum (optional)

Embossing pen or liquid ink (if using embossing powder)

Stamp (optional)

Embossing powder or stamp pad

Embossing heat tool

Card stock or blank cards

Tape

Heavy bond glue stick or double-sided photo squares

Safety supplies from page 20

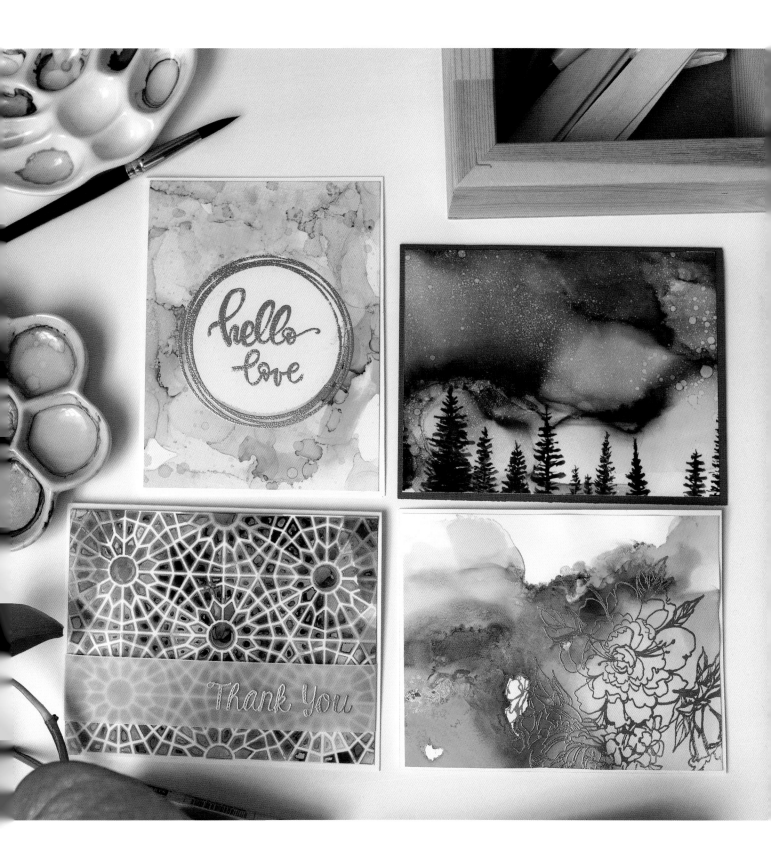

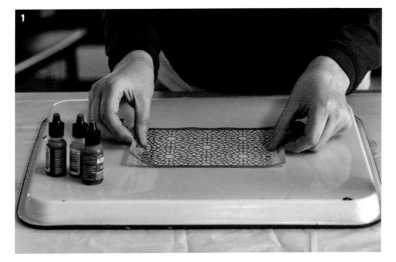

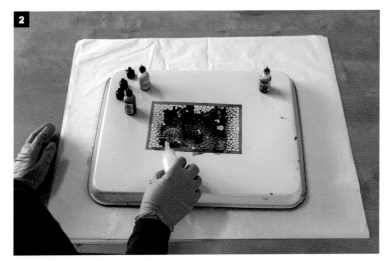

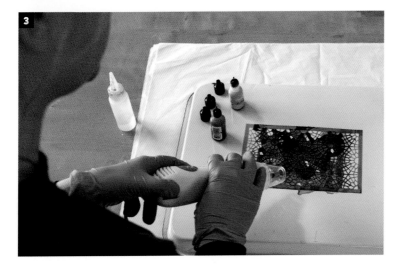

1 Place the Yupo paper on a non-stick surface such as metal or a cutting mat, and be sure to use a surface you don't mind getting ink on. Remove the adhesive stencil from its backing and evenly place onto the Yupo paper, smoothing it down as you go until it has a good bond.

2 Randomly drop two or three alcohol ink colors on top of the stencil along with a good amount of isopropyl to help the ink flow. I used navy, sky blue, and medium warm gray alcohol inks.

3 Apply air to move the alcohol ink and isopropyl mixture across the stencil, filling all the wells of the stencil with ink. Remember, if you are using a heat tool, move it around without concentrating too much in one area because the heat tool can melt the paper and the stencil. If there are places that are too dark, simply pour more isopropyl on to lighten the alcohol ink and add more alcohol ink to spaces where you would like more saturation of color. Let dry.

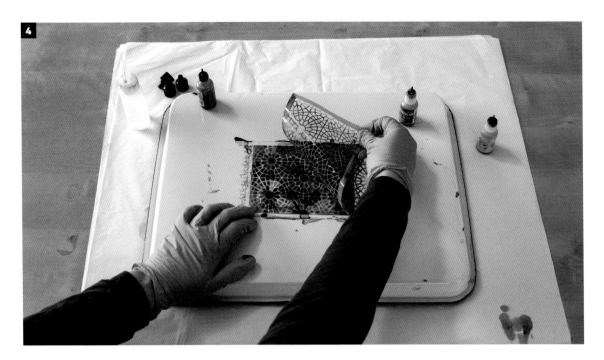

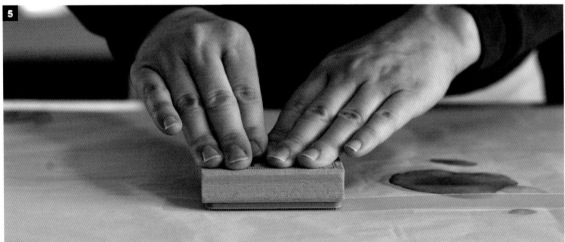

4 Once the alcohol ink is fully dry, peel up one edge of the stencil, revealing the design, and then carefully remove it from the Yupo paper. (Clean it with isopropyl and return it to its original backing to protect it for use in future projects.) Seal your painting following the steps on page 64.

5 You can keep the card blank or add embellishments. I embossed a strip of vellum with "thank you" and placed it over the card. Because vellum is semi-transparent, it will give a little glimpse of the stenciled pattern underneath. You can also use a standard stamp and ink pad instead of embossing. To emboss, take a stamp and press it into an embossing ink pad, making sure you get good coverage. Lay out a strip of vellum and press the inked stamp onto the vellum.

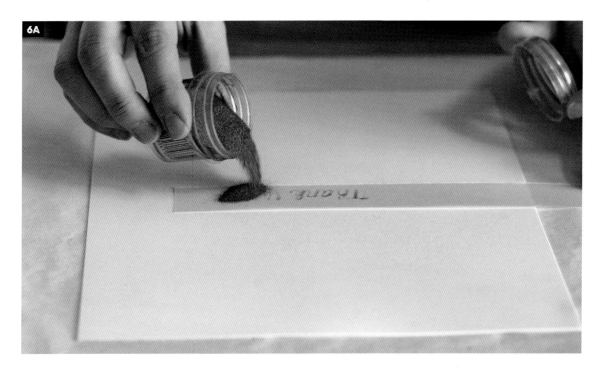

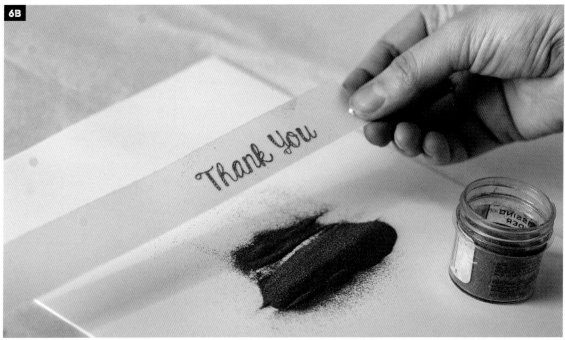

6 Pour the embossing powder on top of the embossing ink **(A)**. Tap any excess embossing powder onto a clean sheet of paper and return it to the bottle **(B)**. Wait 15 minutes and then apply heat with your embossing heat tool to melt the powder.

7 Wrap the vellum around the painted card, taping the overhang to the back of the card **(A)**. Adhere the embellished alcohol ink card to the front of a blank card with a heavy bond glue stick or double-sided photo squares **(B)**. You're finished!

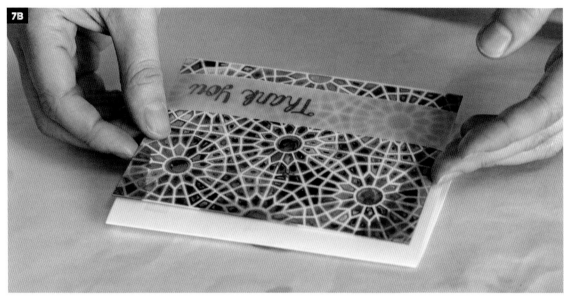

VARIATIONS

There are endless possibilities for creating lovely custom greeting cards. Here are a couple of other ideas to get you started:

• Experiment with cutting custom shapes out of contact paper and painting simple alcohol ink washes on top. Embellish with stamps or embossing powders.

• Paint a simple ink wash and stamp a pretty bouquet on top. This makes a lovely Mother's Day card.

Alcohol Ink Painting on Gessobord

Painting on gessobord is similar to working on Yupo paper; the main difference is that the board will absorb a little of the alcohol ink whereas with Yupo paper, the alcohol ink sits on top of the surface making it easier to reactivate or rework. However, you can still reactivate a dry painting on gessobord and rework it—you will just be left with a very light value of the original color on the surface. You can still use all the same effects as you do with Yupo.

WHAT YOU'LL NEED

Gessobord

Alcohol ink in 3 to 5 colors

Air supply

91% isopropyl or blending solution in a craft bottle

Dropper or small squeeze bottle with pointed tip to apply isopropyl

Safety supplies from page 20

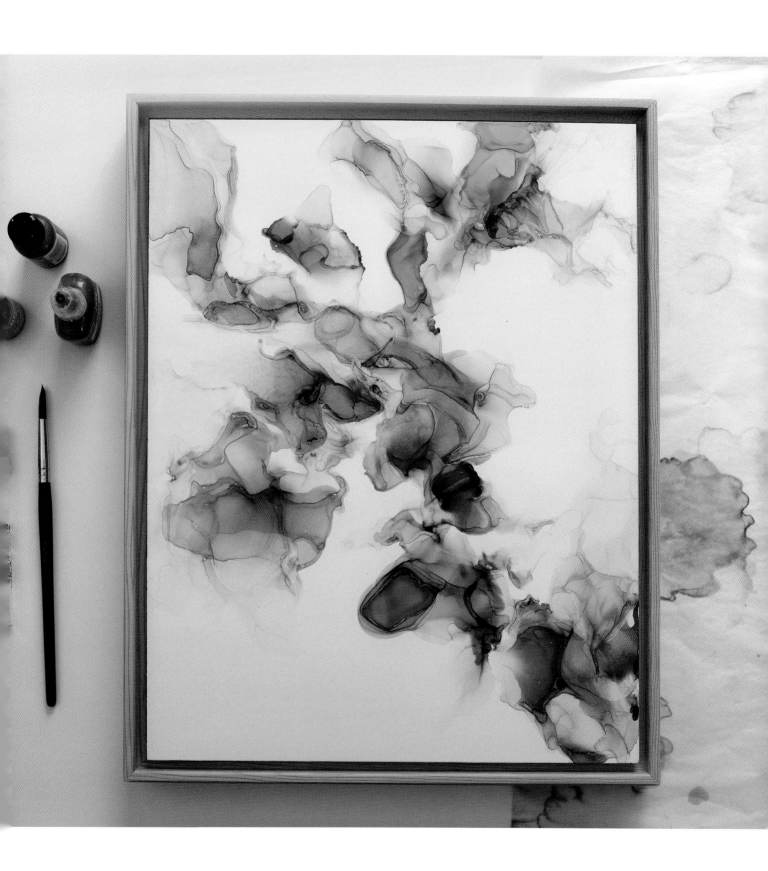

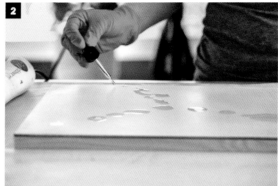

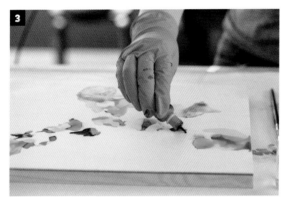

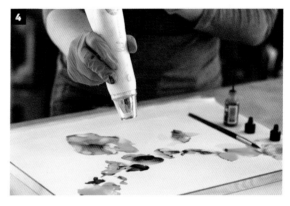

1 Set up a protected workspace and collect your safety and painting supplies. In this demonstration, I worked on an 11" × 14" (28 × 35.6 cm) cradled gessobord that's ¾" (1.9 cm) thick. The cradled board's additional depth allows you to hang it directly on the wall and forgo framing, or you can add a float frame for added support. Select three to five alcohol ink colors.

2 Map out your composition with the isopropyl or blending solution to get a feel for how you want it to flow. As I've said previously, this is just a preliminary step to create a foundation for your composition, but it doesn't mean that you have to stick with that arrangement if the ink starts to lead you in another direction. Just have fun with it!

3 Randomly drop alcohol ink on top of the isopropyl composition. I started by laying down the teal and dark blue. Because I wanted more control of how the pink would interact with the other colors, I waited to add it until the other colors have had time to blend and dry a bit. If you place all the colors down at once, you have less say as to how everything blends.

4 Apply air to the teal and blue alcohol ink until it's almost dry. You'll see pretty textures and blends emerge as the air mixes the two. Add the third color—in this case, pink—and drip a few drops of isopropyl on top to help it to flow. Place the pink where you want to add some visual variety and emphasis. Use the air supply to move it and softly blend it into the blue and teal to create a pretty light purple.

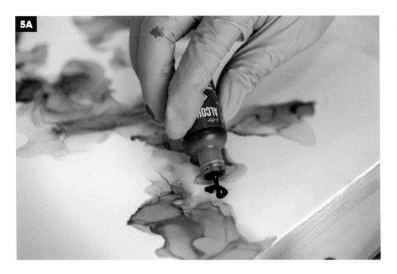

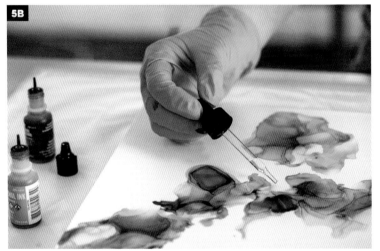

5 At this point, it's normal to see "holes" in the composition. Simply drop in more alcohol ink and isopropyl where you feel you need to visually unite the painting **(A)**. As this is an abstract painting, you'll be the judge of where to fill in these holes and where you want to add a fade to lighten specific areas of the piece. Remember, if you're unhappy with the composition or effect, rework the alcohol ink by adding isopropyl and/or blending solution to the areas you want to alter **(B)**. Keep repeating this step until you're happy with the composition.

6 At the final stage, fade out the edges of specific areas. To do this, select an edge where you want to apply this effect. Add a few drops of isopropyl to the edge and quickly use the air supply to push the ink out to the white space. As you push the ink out, it will fade nicely into the white.

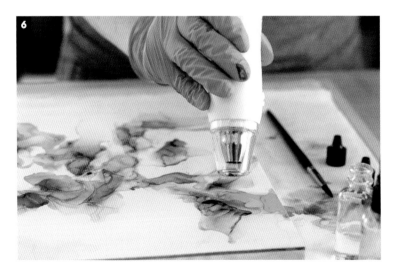

NEXT STEPS

You can add any of the effects shown in Chapter 2, such as the spray effect, stippling, and adding metallic. When finished, seal your painting following the steps on page 64.

Resources

ALCOHOL INKS

Brea Reese
www.breareese.com

Copic Various Ink
https://copic.jp

Jacquard Alcohol Ink Piñata Color
www.jacquardproducts.com

Ranger Tim Holtz
www.rangerink.com

Spectrum Noir Marker Ink Refills
www.spectrumnoir.com

OTHER MEDIUMS & SUPPLIES

Adhesive Stencils
www.marthastewart.com

Embossing Powder and Liquid
www.rangerink.com

Gel Pens
www.gellyroll.com

Matte Gel Medium
www.goldenpaints.com

Modeling Texture
www.breareese.com

Molotow Masking Pen
www.molotow.com

Paint Pens
www.posca.com
www.krylon.com (metallic pen)

Pebeo Masking Pen
www.pebeo.com

PAPERS & OTHER SURFACES

Ampersand
www.ampersandart.com

Brea Reese
www.breareese.com

Legion Paper
www.legionpaper.com

Masterpiece Arts
www.masterpiecearts.com

Maryland China
www.marylandchina.com

Ranger Tim Holtz
www.rangerink.com

FINISHING SUPPLIES

Float Frames
www.ampersandart.com
www.canvasplace.com

Resin
www.artresin.com
Note: You'll also find a helpful resin calculator here.

Varnish & UV Protector
www.krylon.com

ASHLEY MAHLBERG

Shop original paintings, prints, and digital downloads on Ashley's website at www.inkreelstudio.com

Follow Ashley on Instagram: @inkreel

Acknowledgments

I'm so grateful to all the people who had a hand in making this book a reality!
To my editor, Joy Aquilino: I'm so thankful for your encouragement and support throughout this process and for giving me the opportunity to share my love of alcohol ink with the world. Thank you to Marissa Giambrone and her design team. I'm so delighted with the layout and design choices you made to really make this book flow beautifully. I also want to thank my incredibly talented photographer, Steve Johnston, from Exposure Leak: I'm so grateful for the time you spent capturing my process so beautifully.

I want to thank my amazing family. I'm so grateful to my parents, who nourished my creativity from a very young age. My two sisters, Nicki and Steph: Your love and support means everything to me. Thank you to my biggest fans and greatest inspirations: my husband Ray and my precious boy, Max. You guys are my world. Lastly, I thank God for always guiding my steps.

About the Author

ASHLEY MAHLBERG of Ink Reel Studio is an abstract artist and graphic designer. Inspired by the Washington coast, Ashley's work mimics organic forms, flow, and dynamic color palettes found in her everyday surroundings. Ashley licenses her work, shows her art in local commercial spaces, and has been a featured artist on The Crafter's Box (thecraftersbox.com), where she taught alcohol ink techniques. See more of Ashley's work on Instagram (@inkreel), inkreelstudio.com, and Etsy (InkReelArtStudio). She lives in Burlington, Washington.

Index